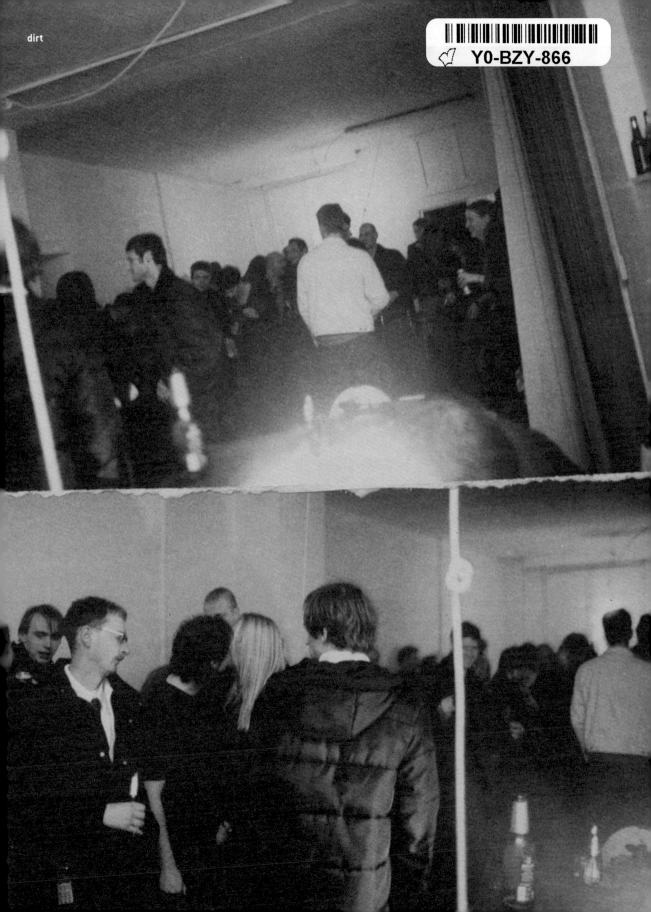

Electric Favela

PACEWILDENSTEIN
545 WEST 22ND STREET NEW YORK CITY

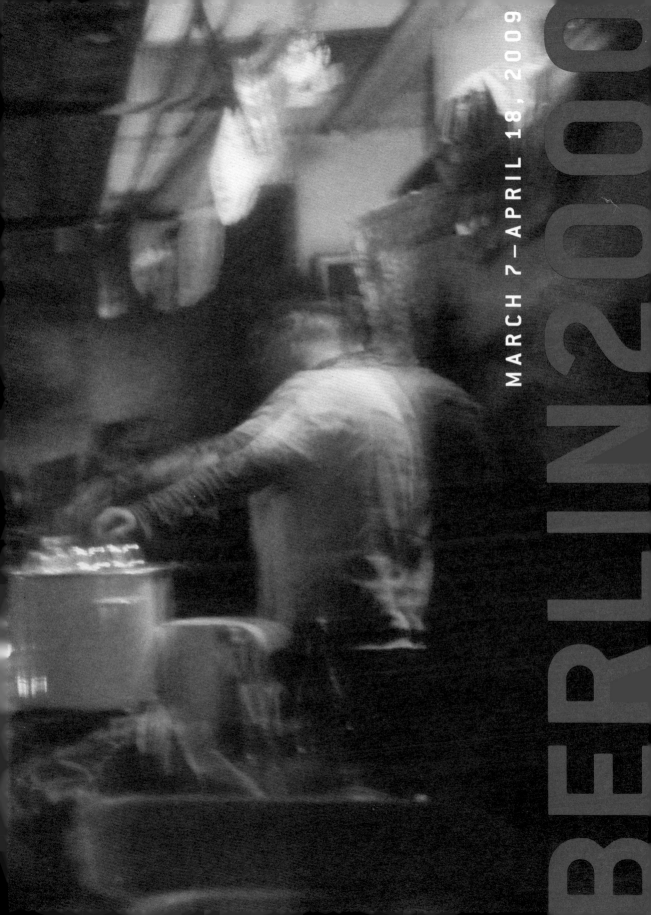

BERLIN2000

MARCH 7–APRIL 18, 2009

Contents

Foreword

Birte Kleemann

In his book, *Goodbye to Berlin*, published in 1930, on which the film *Cabaret* is based, Christopher Isherwood once wrote the following about Berlin:

> From my window, the deep solemn massive street. Cellar-shops where the lamps burn all day, under the shadow of top-heavy balconied façades, dirty plaster frontages embossed with scrollwork and heraldic devices. The whole district is like this: street leading into street of houses like shabby monumental safes crammed with the tarnished valuables and second-hand furniture of a bankrupt middle class.(. . .). At eight o'clock in the evening the house-doors will be locked. The children are having supper. The shops are shut. The electric-sign is switched on over the night-bell of the little hotel on the corner, where you can hire a room by the hour. And soon the whistling will begin. Young men are calling their girls. Standing down there in the cold, they whistle up at the lighted windows of warm rooms where the beds are already turned down for the night. They want to be let in.[1]

Seventy years later, Isherwood's description still captures the atmosphere of life in Berlin. The mixture of "big city" and quirky neighborhood, is manifest on every street corner.

Berlin is perhaps the only European capital with this synthetic structure at the heart of its design. First mentioned in 1237 as Cölln and composed of several towns, Berlin did not become the capital of Prussia until 1701. Eventually, Berlin became connected, if not exactly integrated, by a system of overlapping rings and main arteries. Mirroring its diverse landscape, Berlin's familiar history is, of course, the ultimate expression of this patchwork nature. From the Wilhelminian capital, to the center of the Third Reich, from the symbol of the divided Germany to the site of its reunification; this fundamental 'mixed feeling' remains the city's essential characteristic. Then as now, the city is not defined by a center, but rather by a constantly shifting complex of autonomous boroughs.

This exhibition seeks to demonstrate how that nature has been equally decisive in the life of the city's artists and how, at one particularly catalytic moment, Berlin's multicenter personality provided the ideal conditions for the explosion of innovation that marked her art world at the last moments of the 20th century.

BERLIN2000 uses as its premise a year which is now nearly ten years in the past and, more importantly, marks ten years of change and development since the fall of the Berlin Wall. For decades before the fall of the wall, the city attracted artists from America and the rest of Europe, just as it had after the fall of the Kaiser. Whether it was Edward Kienholz or Jim Dine or David Bowie and Iggy Popp, Berlin never ceased to exert its pull as a place where the past could be held at bay even while one lived amongst the rubble and evidence of its results.

But shortly after the wall fell, the flow of international artists into the city started to become greater and markedly younger. Artists like Damien Hirst, Tacita Dean and Mark Wallinger pursued their DAAD fellowship (established in 1963 by the Ford Foundation, becoming DAAD in Berlin in 1965) there, others came for one-year Bethanien Fellowships, often staying for much more than the allowed year. Others, like Elmgreen & Dragset and Candice Breitz came to town and just never went back. But while this was happening, a wave of young German artists from all corners of the nation was starting to build and by the mid-1990s, was washing over the boroughs and neighborhoods of the newly revealed landscape of East Berlin.

In a divided Berlin it had been Kreuzberg, cheap and close to the border, where intellectuals and artists gathered and organized. After the wall fell, the East, consisting in large

part of vacant spaces and crumbling structures, offered the districts of Berlin-Mitte and Prenzlauerberg as a sort of post apocalyptic wonderland. Soon the new residents were setting up clubs and exhibition spaces, like the infamous *panasonic*, *dirt*, *Maschenmode*, *Friseur*, *Botschaft*, *Sniper*, *Init*, *BerlinTokyo*, *Kunst und Technik*, *G7*, *Finks* and *Montparnasse*.

Naturally, documenting the fruit of ten years of post-wall Berlin could be the subject of innumerable exhibitions and publications, as indeed it has been. Therefore, BERLIN2000 attempts a snapshot (and a partial one at that) through the work of some of these artists as they created and recreated a new set of centers and neighborhoods in the vacant housings and abandoned premises of the eastern part of the city.

To obtain a consistent picture, during the course of organizing the exhibition we came to intentionally concentrate on a few particular spaces that had taken root at that time. Furthermore, in order to pay due attention to the exclusiveness of each network, we have chosen to present a number of specific artist's circles. Artists' groups are based strongly on personal liking, as the 2001 group exhibition *Sympathie!* organized by Wawa Tokarski at *Montparnasse* shows.

This exhibition turns upon initiators such as Dirk Bell, Anselm Reyle and Thilo Heinzmann who offered other artists, friends and also themselves opportunities to display their work. A central thought was that of an exchange of views, preferably with a glass of beer in one's hand. Often, as with Jenny Rosemeyer and Oranienburger Straße 3, there were exhibitions for one evening where almost thirty artists presented their works together.

The exhibition presents artists around Baudach's Maschenmode (the name was adopted from the business that was previously situated on the same premises), which was opened by Martin Germann, Peter K. Koch and Guido W. Baudach in 1999, a selection of artists that showed with galleries such as *Koch und Kesslau* and *Giti Nourbakhsch*, and artists who otherwise exhibited in off-spaces such as *Andersen's Wohnung*, *Montparnasse*, *Pavillon an der Volksbühne*, *loop* and *G7*.

There is also a group of artist friends such as Johannes Kahrs, Daniel Pflumm, Monica Bonvicini, John Bock, Carsten and Olaf Nicolai, Manfred Pernice, Karsten Konrad, Gunter Reski and Frank Nitsche who already a few years earlier, in the mid-1980s and early 1990s, had lived and worked in Berlin, and therefore have naturally different recollections of earlier times than artists who only came to Berlin later, say, after completing their studies. The exhibition hence spans two generations of artists who have decided consciously in favor of the city as the place where they live and work.

My thanks are due first and foremost to the artists for putting together an excellent exhibition in such a short time. Often they have selected very special works so as to present their Berlin before and around the year 2000. As you will see in the biographies, we have restricted ourselves to requesting the artists to provide their own articles, with a focus on what they were doing at that time and what their favorite places were. The same applies to the photographic material that some artists have retrieved from their archives and which in many cases is being shown here publicly for the first time. I hope, therefore, that this exhibition gives back to the participating artists, and brings together what constitutes the city for them.

I am very glad that we were able to entice Marcus Steinweg to write *23 Theses on art, philosophy, truth and subjectivity*. We have also made available articles from the year 2000 by Gunter Reski, Ariane Müller and Andreas Koch.

STARSHIP compiled an exceptional publication especially for this show, containing articles in both German and English.

For the exhibition, Tilman Wendland worked out a site-specific installation on which and in which you can inspect various publications about Berlin, associated writings, films and monographs by the artists.

To communicate Berlin and its off-spaces would be nothing without the appropriate bar, and so we are happy that, together with Art Production Fund, we have been able to set up a bar for the opening weekend where, in addition to a performance by John Bock, there will be music in the evenings from various Berlin artists.

Thanks also go to all the galleries who have comprehensively supported and enabled this exhibition project.

Especially in the last decade Berlin has found many enthusiastic visitors. We are therefore very pleased to be able to present for the first time in a comprehensive way, this city's phenomena. And, with a selection of 37 artists, bringing Berlin closer to an interested public from a new perspective.

Note:

1. Christopher Isherwood, "A Berlin Diary (Autumn 1930)," in *Goodbye to Berlin* (Stuttgart: Philipp Reclam jun. GmbH & Co., 1994), pp.7–8.

Vorwort

Birte Kleemann

Christopher Isherwood hat in seinem 1930 erschienenen Buch: *Goodbye to Berlin*, das die Vorlage für den Film *Cabaret* lieferte, einmal folgendes über Berlin geschrieben:

Unter meinem Fenster die düstere Straße, eine massive Pracht. Kellerläden, in denen tagsüber Licht brennt, im Schatten gewaltiger, balkongeschmückter Fassaden, schmutziger Stuckfronten mit hervorquellenden Schnörkeln und heraldischen Symbolen. Das ganze Viertel ist so. Straßauf, straßab Reihen von Häusern, gleich schäbigen Riesengeldschränken, die vollgestopft sind mit den verblichenen Kostbarkeiten und mit den zweitklassigen Möbeln einer bankrotten Mittelschicht. (...) Um acht Uhr abends werden die Haustüren zugemacht. Die Kinder bekommen ihr Abendbrot. Die Geschäfte sind geschlossen. Über der Nachtglocke des kleinen Hotels an der Ecke, wo man Zimmer stundenweise mieten kann, wird das Leuchtschild eingeschaltet. Und bald hebt das Pfeifen an. Junge Männer rufen ihre Mädchen. Sie stehen unten in der Kälte und pfeifen hinauf zu den hellen Fenstern warmer Zimmer, in denen die Betten für die Nacht schon gerichtet sind. Sie möchten eingelassen werden.[1]

Auch 70 Jahre später lässt sich kaum eine bessere Umschreibung des Berliner Lebensgefühls finden. Noch immer lebt Berlin von dieser Mischung aus Großstadt und regionalem Kiezgefühl, dass sich an jeder Straßenecke manifestiert.

Berlin ist vielleicht die einzige in ihrer Grundstruktur modern angelegte europäische Hauptstadt. 1237 zum ersten Mal als Cölln erwähnt, setzt sie sich aus ursprünglich mehreren Städten zusammen und erhielt unter König Friedrich I. von Preußen 1701 erstmals Hauptstadtstatus. Verbunden sind diese momentanen 12 Stadtteile durch ein System aus sich kreuzenden Ringstraßen und Hauptachsen. Auch heute, nachdem Berlin unterschiedliche historische Epochen erlebt hat — wilhelminische Hauptstadt, die Zeit nach dem Kaiserreich, das Berlin des deutschen Nationalsozialismus, eine geteilte Stadt zweier Deutschlands und seit 1990 die Hauptstadt eines wiedervereinigten Landes-, hat sich an dem grundlegenden Charakter der Stadt kaum je etwas geändert. Damals wie heute ist Berlin durch seine einzelnen autarken Stadtteile bestimmt.

Dieser multizentrische Charakter, der sich auf die in Berlin lebenden Künstler im täglichen Arbeitsrhythmus prägend auswirkt, bildete — in diesem entscheidenden Moment am Ende des 20. Jahrhundert auf den sich die Ausstellung konzentriert — die ideale Grundvoraussetzung für die explosionsartige Neubelebung der Stadt als ein Zentrum der zeitgenössischen Kunstwelt.

BERLIN2000 erlaubt aus heutiger Sicht einen Blick um zehn Jahre zurück und markiert gleichzeitig zehn Jahre des Wandels und der Entwicklung einer widervereinigten Stadt nach dem Mauerfall.

Über Jahrzehnte, bereits vor dem Mauerfall — damals West-Berlin — war die Stadt, wie schon einmal nach dem Ende des Kaiserreiches, auch ein attraktiver Arbeitsort für Künstler aus Amerika und Teilen Europas. Ob Edward Kienholz oder Jim Dine, David Bowie oder Iggy Popp: immer hat Berlin durch seine Fähigkeit, sich auch angesichts seiner Geschichte immer wieder neu zu erfinden, seinen Reiz auf seine Besucher ausgeübt.

Kurz nach dem Mauerfall wurde der Zuzug internationaler Künstler erheblich größer und auch in seiner Altersstruktur sichtbar jünger. Künstler wie Damien Hirst, Tacita Dean und Mark Wallinger kamen über ein DAAD Stipendium (1963 von der Ford Stiftung etabliert und 1965 dann als DAAD in Berlin

1. *Genre Painting*
Group exhibition curated by Gregor Hildebrandt, Marc Pätzold, Susanne Roewer and Roger Wardin at G7, Oranienburger Straße, 2000. The exhibition featured over a hundred artists, including Dirk Bell, Axel Geis, Sebastian Hammwöhner, Thilo Heinzmann, Thomas Helbig, Uwe Henneken, Andreas Hofer, René Lück, Michel Majerus, Gunter Reski, Anselm Reyle, Jenny Rosemeyer, Thomas Scheibitz, Dirk Skreber, Gert and Uwe Tobias, Wawrzyniec Tokarski, Gabriel Vormstein, Suse Weber and Thomas Zipp.

2. *Pavillon an der Volksbühne*
Exhibition space located on Rosa-Luxemburg-Platz. From 1997 to 1998 curated by Rüdiger Lange (loop-raum für aktuelle kunst) with an extensive exhibition program and regular public screenings of crucial soccer matches. *ready mix*, 1997, the inaugural exhibition by Erik Göngrich is shown.

3. *Deutsch Britische Freundschaft: DIE GEFAHR IM JAZZ*
Poster for the group exhibition organized by Thomas Helbig, Keith Farquhar (Deutsch Britische Freundschaft) and Lucy McKenzie, Straßburger Straße, 2000.

4. *Sympathie!*
Flyer for the group exhibition curated by Wawrzyniec Tokarski at Montparnasse on Marienstraße, 2000. The exhibition included artists such as Plamen Dejanov & Swetlana Heger, Dieter Detzner, Heike Föll, Sebastian Hammwöhner, Uwe Henneken, Stephan Jung, Maureen Karcher, Michel Majerus, Karin Pernegger, Anselm Reyle, Susa Reinhardt, Heidi Specker, Katja Strunz, Alexandra Trenséni, Gabriel Vormstein and Klaus Winichner.

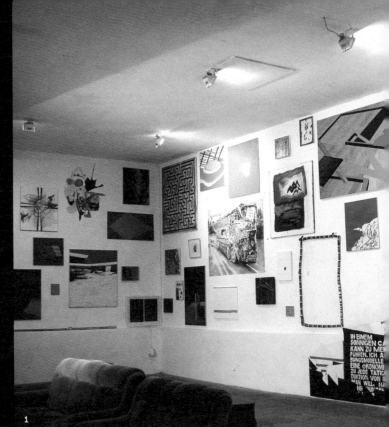

1

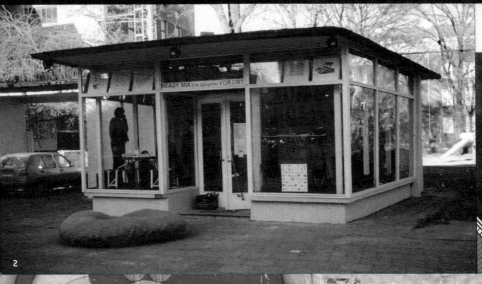

2

Deutsch Britische Freundschaft

DI
GEFAHR I
JAZ

3

...er der Liebe und Freundschaft

YMPATHIE

...men Dejanov & Swetlana Heger Dieter Detzner Heike Föll
...astian Hammwöhner Uwe Henneken Stephan Jung Maureen Karcher
...el Majerus Karin Pernegger Anselm Reyle Susa Reinhardt Heidi Specker
...a Strunz Alexandra Trencséni Gabriel Vormstein Klaus Winichner

SCHALL&RAUCH
von Sebastian Hammwöhner, Uwe Henneken, Gabriel Vormstein und Katja Strunz
2 Juni 2000, 20:00

4

ansässig) in die Stadt . Einige andere verlängerten privat ihr einjähriges Stipendium des Künstlerhauses Bethanien. Auch Elmgreen&Dragset und Candice Breitz leben heute in Berlin. Gleichzeitig zog Mitte der 1990er Jahre eine noch jüngere Generation von Künstlern aus allen Ecken Deutschlands nach Berlin, um die nun zugänglichen Ost-Teile der Stadt für sich zu erobern.

In einem geteilten Berlin war es das grenznahe und kostengünstigere Kreuzberg, in dem sich Intellektuelle und Künstler trafen und organisierten. Nach dem Mauerfall mit einem in großen Teilen leerstehenden—und somit auch kostenlos verfügbaren—Ostteil waren es die Stadtteile Mitte und Prenzlauer Berg, in denen sich Clubs und Ausstellungsorte wie *panasonic, dirt, Maschenmode, Friseur, Botschaft, Sniper, Init, BerlinTokyo, Kunst und Technik, G7, Finks* und *Montparnasse* ansiedelten.

BERLIN2000 ist daher nicht der Versuch, eine möglichst heterogene Auswahl zu treffen und alle Medien und internationalen Künstler gleichermaßen zu berücksichtigen. Es ist auch nicht der Versuch die Entwicklung der Stadt Berlin photografisch festzuhalten. Sondern die Ausstellung basiert, ausgehend von den Orten die sich damals nach der Maueröffnung in den neuen Teilen der Stadt auftaten, auf die darum gruppierten Künstler. Es handelt sich somit auch um eine persönliche Sichtweise auf die damaligen Strömungen und kreativen Orte.

Um ein schlüssiges Bild zu erhalten, haben wir uns im Zuge der Ausstellung bewusst auf ein paar der Räume von damals konzentriert, auch um dem Grundcharakter der um 2000 bestehenden Netzwerke Rechnung zu tragen. Sind doch Künstlergruppen stark auf Sympathien basierend, wie die gleichnamige Gruppenausstellung, 2001 von Wawa Tokarski im *Montparnasse* organisiert, so einleuchtend verdeutlicht.

In dieser Ausstellung geht es um Initiatoren wie Dirk Bell, Anselm Reyle und Thilo Heinzmann, die anderen Künstlern, Freunden und sich selber Ausstellungsmöglichkeiten boten. Zentral dabei auch der Gedanke des Austauschens, gerne mit einem Bier in der Hand. Oft gab es wie zum Beispiel auch bei Jenny Rosemeyer in der Oranienburger Straße 3 Ausstellungen für einen Abend, in der dann knapp 30 Künstler gemeinsam ausstellten.

Die Ausstellung zeigt Künstler um Baudach s *Maschenmode* (der Name wurde von dem vorherigen Geschäft an gleicher Stelle übernommen), das 1999 von Martin Germann, Peter K.Koch und Guido W. Baudach eröffnet wurde; wie auch eine

Auswahl an Künstlern, die *Koch und Kesslau* ausgestellt haben. Ebenso *Giti Nourbakhschs* Künstler und Leute, die in off-spaces, wie *Andersens' Wohnung, Montparnasse, Pavillon an der Volksbühne, loop* und *G7*, präsent waren.

Es gibt zudem eine Gruppe von befreundeten Künstlern wie Johannes Kahrs, Daniel Pflumm, Monica Bonvicini, John Bock, Carsten Nicolai, Olaf Nicolai, Manfred Pernice, Karsten Konrad, Gunter Reski und Frank Nitsche, die bereits seit Mitte der 1980er und frühen 1990er Jahre in Berlin leben und arbeiten, und somit andere Erinnerungen an BERLIN2000 haben, als diejenigen, die erst zu einem späteren Zeitpunkt, zum Beispiel nach Abschluss des Studiums, nach Berlin umgezogen sind. Somit umfasst die Ausstellung zwei Generationen von Künstlern, die sich bewusst für die Stadt als Arbeits- und Lebensort entschieden haben.

Mein Dank gilt vor allem den Künstlern, die geholfen haben, in der Kürze der Zeit eine hervorragende Ausstellung zusammen zu bringen. Sie haben dabei oft ganz besondere Arbeiten ausgewählt, um ihr Berlin in der Zeit vor und um 2000 darzustellen. Wie Sie sehen werden, haben wir uns zudem bei den Biografien darauf beschränkt, die Künstler um eigene Beiträge zu bitten, mit einem Schwerpunkt darauf, was sie damals gemacht haben und welches ihre Lieblingsorte waren. Das gleiche gilt für das Bildmaterial, das einige Künstler in ihren Archiven zusammengesucht haben und das hier oft zum ersten Mal veröffentlicht wird. Ich hoffe daher, dass diese Ausstellung den beteiligten Künstlern das auf einer Ebene zurückgibt und zusammenfügt, was die Stadt für sie ausmacht.

Es freut mich sehr, dass wir Marcus Steinweg für seinen 23-Thesenkatalog zu Kunst, Philosophie, Wahrheit und Subjektivität gewinnen konnten. Zudem haben uns Gunter Reski, Ariane Müller und Andreas Koch Textbeiträge aus dem Jahr 2000 zur Verfügung gestellt.

STARSHIP hat eigens für die Ausstellung eine Sonderpublikation verfasst, die Textbeiträge in deutsch und englisch beinhaltet .

Tilman Wendland hat für die Ausstellung eine ortsspezifische Installation erarbeitet, auf und in der Sie verschiedene Publikationen über Berlin, begleitende Schriften, Filme und die Monografien der Künstler einsehen können.

Berlin und seine off-spaces zu vermitteln wäre nichts ohne eine entsprechende Bar, und so freuen wir uns, dass wir gemeinsam mit Art Production Fund eine Bar für das

Eröffnungswochenende einrichten können, die neben einer Performance von John Bock abends von verschiedenen Künstlern aus Berlin musikalisch bespielt wird.

Mein Dank auch an alle Galerien, die dieses Ausstellungsprojekt umfangreich unterstützt und möglich gemacht haben.

Berlin hat gerade in der letzen Dekade viele begeisterte Besucher gefunden, es freut uns daher sehr, hier zum ersten Mal in einer umfangreichen Ausstellung diese 37 ausgewählten Künstler gemeinsam vorstellen zu können und somit Berlin in einem neuen Blickwinkel einem interessierten Publikum näher zu bringen.

Note:

1. Christopher Isherwood, "Berliner Tagebuch (Herbst 1930)," in *Leb Wohl, Berlin* (Berlin: Ullstein Buchverlage GmbH, 2004), pp. 9–10.

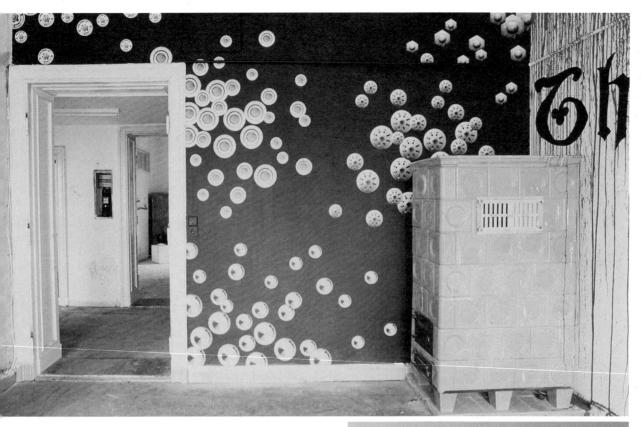

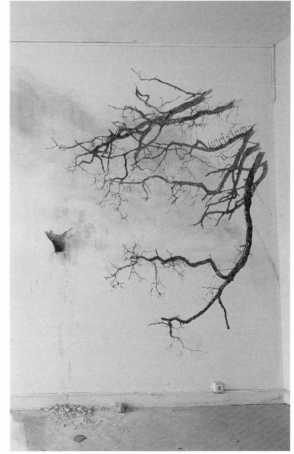

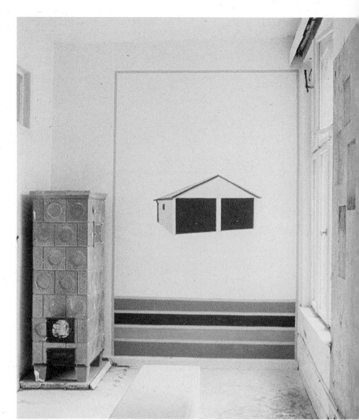

WANDBILDER

Group exhibition curated by Jenny Rosemeyer and Axel
Geis. The exhibition was held at Atelier Jenny Rosemeyer,
Oranienburger Straße 3, 2001. The exhibition included
artists such as Martin Eder, Berta Fischer, Marten Frerichs,
Axel Geis, Sebastian Hammwöhner, Thilo Heinzmann,
Uwe Henneken, Gregor Hildebrandt, Olaf Holzapfel,
Simone Hülser, Dani Jakob, Lisa Junghanß, Erwin
Kneihsl, Andreas Koch, René Lück, Martin Neumeier,
Rocco Pagel, Manfred Peckl, Anselm Reyle, Thomas
Scheibitz, Katja Strunz, Gabriel Vormstein, Suse Weber
and Eva-Maria Wilde.

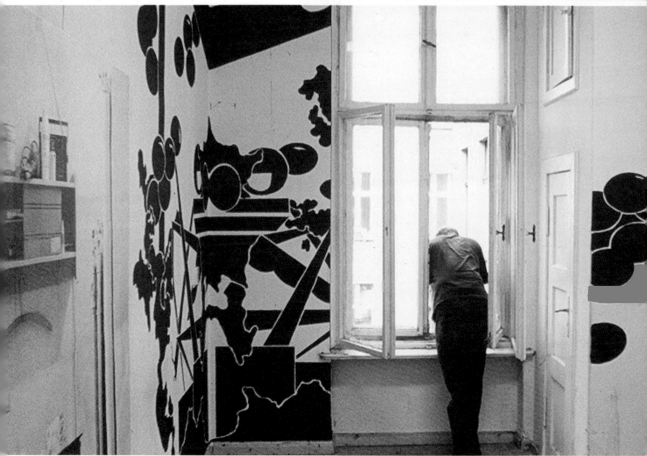

23 Theses on Art, Philosophy, Truth and Subjectivity

1. Art & philosophy are contacts with truth insofar as we understand by truth something that does not exist.

2. I call truth that which afflicts any knowledge, any opinion, any reality with inconsistency, thus threatening the stability of every construction of knowledge, opinion, and reality.

3. One aspect of truth is that it is not present like a being. Truth does not have any ontological positivity at all. Nevertheless, art & philosophy are related through their opening toward this dimension of non-positivity and inconsistency which I call truth or incommensurability. Art and philosophy refuse to come to an arrangement with reality in its status as given. Therefore they extend to truth because this extension means confronting reality with its truth as the incommensurability implicit within it.

4. I call reality the world as it is and appears, the world of options, of communication, of circulating values, laws and rules. A material as well as a spiritual world of collective fantasies, fears, and hopes. Cosmos of warlike, sentimental, economic conflicts. World full of images, world of language, of information and critique. Historical world, heterogeneous field of cultural, local, geopolitical differences. Space of consistency or universe of familiarity in which, in spite of everything, people can live.

5. Truth is that which carries a certain unliveability into this space of liveability. Truth is the name for the interruption of the system of possibilities. To access truth means to come into contact with the impossible, with the impossible as well as with that which cannot be communicated any further, with the beyond of information and the beyond of language. Thus, with that which can only be experienced as resistance in the here-and-now of the one world. Truth is therefore the name of that which resists.

6. There is only one world. There is no second world, no hinterworld, no utopian place. But this one world without an exit is in no way identical with its representations in images, information, and language. Rather, it has its own incommensurability that refuses any direct appearance. It denotes nothing other than the inconsistency of this universe of consistency we call reality.

7. With the truth, an elementary unfamiliarity is announced that belongs originally to the layer of familiarity which is our world.

8. Art & philosophy touch this unfamiliarity in order to point to an instability or indifference which demonstrates the ontological insecurity of all constructions of sense and works. Herein lies the critical power of art and philosophy: they point the way to the irreducible non-sense that remains the truth of all architectures of meaning and procedures generating sense.

9. Sense and meaning are inventions whose credibility is measured in proportion to the degree of their openness to the dimension of non-sense, i.e., to truth. Only the sense which maintains contact with non-sense, only the meaning which maintains an intimacy with meaninglessness are relevant to art or philosophy.

10. Only that art is credible which has the courage to open up toward the incommensurable. The form-assertions of art are such tests of courage which, as the precondition for art, affirm the refusal to come to an arrangement with recognized realities.

11. Art and philosophy are practices of self-elevation in the here-and-now of the one reality. Only in this engagement with the world's arrangements and ways of functioning in its current form can a resistance be inscribed, in it that

the distance between the self-interpretation of these arrangements and functions, on the one hand, and the incommensurable aspects denied, repressed, and ignored by them, on the other. There is no art which could evade this articulation, no matter how implicitly this may happen, because only the distance from reality gives the art work its form that stands apart from reality.

12. Distance is the condition of possibility of every artistic articulation that resists the temptation to be assimilated into existing reality. I call the established, existing world: reality or the world of facts. One aspect of a fact is that it denies its inconsistency. The insistence on facts regularly has the function of excluding an access to truth by pointing to its impossibility. The sense for facts is the brother of sound commonsense.

13. What the sense for facts tries to cover up is the circumstance that every certainty, all evidence, hovers above the abyss of a truth that does not exist. The sense for facts has the function of preventing the necessarily risky contact with this abyss by never ceasing to contest the ontological efficiency of that which does not exist. That something does not exist ostensibly means that it remains without effect. Precisely speaking, a truth or nothingness has inexorable efficiency. If we equate truth with the incommensurable, then we can assert that subjects exist who don't care one whit about truth. There is truth, by contrast, only as that which no subject forgets. Gottfried Benn insisted on this efficiency, as Heiner Müller recalls, by conceiving of art as a "performance against nihilism." [1] That there is nothingness means simply that reality is not everything, even though it is the only reality. Everything that counts in art and philosophy opens up toward nothingness by refusing to fall victim to it. It is always a matter of formulating an infinitesimal distance from nothingness, from truth, from incommensurability. The active nihilism of an access to truth is distinguished from the passive nihilism of a refusal of truth by articulating a minimal resistance vis-à-vis the incommensurable. The problem of art & philosophy will never be anything other than the attempt to move on the same plane as nothingness, at eye level with the abyss of truth.

14. That is the fundamental experience of art & philosophy, this contact at eye level with that which blinds thinking. There is an access to truth only as the experience of this blindness that emancipates the subject from the dictates of knowledge, of control, of property. There is no art and no philosophy beyond knowledge and a certain comprehensibility, but in this knowledge and understanding,

a blindness and non-understanding are already at work which drive the thinking of art and philosophy beyond their possibilities. We do not think as long as we think that thinking is first of all a critical act, analysis, reflective intelligence. In every critique, every analysis, every reflection, an affirmation is implicit that maintains contact with the unknowable. Thinking always moves toward the unthinkable, toward the totality of that which evades its categories. Only here does thinking begin, at the limits of its impossibility, as an acceleration beyond established evidence, as a full-hearted affirmation of all that which we do not understand and which thus calls for thinking. To move on the same plane as nothingness, therefore, means to think on the plane of our weaknesses, of our incapacity to think, instead of succumbing to the illusion of a knowledge controlling everything. Being in contact with truth includes an opening of the subject to its exterior which it itself does not possess and cannot bring under control. The subject of art & philosophy is in this sense a subject with its switch turned on toward its incommensurability.

15. Thinking is a thinking with its switch opened, or it is nothing at all. The reproduction that belongs to every thinking, the redistribution of the material, the ideas and concepts, their fragmentation and connection with something apparently wholly different, have to open up toward the opportunity of the new which necessarily appears as chaos, as disorder. The subject's self-release toward the new is a part of it by definition. There is something resembling a subject only as an original missing of the self, as a surpassing and transgressing of the self from the outset. Instead of being the product of a narcissistic self-enclosure, as self-consciousness, etc., the subject experiences itself as an original exteriority toward the spheres of non-sense, of otherness, of the impossible. The release to this area is not merely subsequent. Rather, the subject is always already related to something that is a part of it by withdrawing from it. All the subject's acts and decisions remain held by this withdrawal, related to an emptiness, an absence, a hole in being. Thus related to an otherness which announces itself as an unfamiliarity or eeriness that causes the subject to again and again fall out of step by confronting it with the contingency and non-closure of its reality.

16. It is this non-closure that has become the care and concern of thinking, this unsettledness in being, this expansive power which, like a blind vector, relates even the most decisive, the most rational acts of the subject to an incommensurability which limits a priori the power of understanding, of reason as well as of any calculus.

The space of this limitation remains the essential living space, the subject's only reality. Here it articulates its hopes and fears, in the here-and-now of an irreducible intransparency. Therefore it makes sense to affirm this reality as the dimension of a certain blindness in which the subject can do nothing other than to decide *nevertheless*, to act *nevertheless*, to live *nevertheless*, since its decisions have to be made in the undecidable, and its actions bring it before its limits, and its form of living remains open toward the unliveable.

17. Thinking in concepts includes extending to that which is exterior to the concepts, to the implicit impossibility of a conceptual grasp of being and the world. The concept is adjacent to the domain of the non-conceptual. It exists only in the form of this touching of the limit, as a transgression, surpassing, transcending or excess, as a form outside itself which no longer closes itself off to the formlessness of pre-conceptual entities. The dimension of the pre-conceptual can be denoted as the order of the pre-synthetic trace, as the domain of the *gramma* (Derrida) or, in Agamben's terminology, of the voice, as the dimension of a difference and limit that reveals itself to conceptual desire as resistance.[2] I call this space the domain of the incommensurable, whereby it becomes indispensable to insist that the incommensurable does not mean any kind of sublime beyond, but this crevice in the concept itself that marks the difference in identity, a difference that has not ceased to afflict identificational thinking from its beginnings. It is this presence of difference in the thinking of presence called metaphysics that makes the simple distinction between metaphysical and trans-metaphysical (deconstructive, etc.) thinking, as Derrida himself would say, infinitely complicated. *Infinitely* in the sense of the sense of infinity defended by Blanchot, which aims at the impossibility of closure and cessation. Complicated in the sense of the impossibility of a satisfying pacification of conceptual thinking in binary models. The relationship between presence and absence, identity and difference, the conceptual and the non-conceptual will not bend to any hierarchical structure which subjugates one element to the other for the sake of its pacification, thus inflicting a kind of conceptual injustice upon it. On this conceptual injustice, on the *injustice of the concept*, Adorno and Derrida, as well as many others, have said what it is most necessary to say. Agamben, in turn, rightly insists that this thinking called metaphysics, instead of being simply the name of this injustice, cannot itself be sacrificed to it since it is nevertheless itself more complicated or complex than injustice would like to have it. Metaphysical thinking already includes this self-extension of the concept to its dark ground, which Agamben describes as the abyss of negativity.

18. Western thinking lives of the illusion of identity and self-equality of the human subject. It is always concerned with the question, Who am I? This question is always answered by promising the ego a home, a transcendental intimacy and familiarity with itself. And yet it is obvious that this will and this desire and the ethics which such a self-stabilization in an entity called ego or self demands are indebted to an ontological catastrophe, to the inkling, the knowledge that there is no subject identical with itself. Perhaps there is something resembling a subject, but it does not agree with itself.[3] Philosophy holds itself as far as possible away from the phantasma of self-possession, from the illusion of full speech that dominates the logos of factual certainties or *doxai*. Philosophy exists only as long as it blocks itself off from this phantasma and the illusion of self-possession, as long as it recognizes a movement of primordial self-expropriation, as long as it grasps that the non-logos or ante-logos dwells already in the heart of the logos. The logos is an openness to chaos; the logos-subject is only *by itself* by being *outside itself*, *beyond itself*. That is the implicit madness of the logos, its hyperbolism, that it exists only as a touching of its limits. "The human being," writes Hans Blumenberg, "according to its origin, is bound to the principle of superfluity, of luxury. From the very first moment, walking upright was luxurious: to see that which is not yet present, that which is *not yet an acute necessity*, to exercise prevention in relation to that which is only a non-bodily impossibility, a potential threat or enticement— that is always something associated with an excessive effort and not by accident is also the beginning of all *aggression* as well as the possibility of its cessation."[4] The logos-subject includes this superfluity, this exaggeration, this too-much, this transcendence of its momentary situation.

19. Philosophy knows its own velocity. Sometimes its acceleration lies in reticence, in a certain abstinence in relation to the *problems of the times*. Sometimes philosophy accelerates by decelerating, by slowing down or playing dead. The power of philosophy lies in this acceleration which is something other than the opposite of deceleration. The self-acceleration of philosophy means its opening toward the dimension of the undecidable, of the future, of contingency. The self-affirmation of the philosophical subject as the subject of this opening is a necessarily precipitous affirmation. The subject affirms what it does not know. The self-acceleration of philosophy is such a precipitousness. Who would want to assert that there is no precipitousness also as an abstinence from its times, as a discretion vis-à-vis the Zeitgeist, as long as the latter's compulsions to accelerate work toward cementing established realities? Philosophy

exists only as a philosophy of assertion. An assertion is always too fast, always over-hasty, always exaggerated and headless. And yet, philosophical assertion knows its own precision. Philosophy is a form of living that tears the subject away beyond its certainties. The subject of philosophy accelerates beyond its objective reality in the established field of reality. It affirms itself as the authority of actions which it no longer controls. Philosophy's experience of time is the experience of this lack of control, the experience of fragility, of ontological indeterminacy, i.e., of construedness, of the fictitious status of its times and reality. At no point in time in the history of philosophy was philosophy concerned with formulating "views on the times." Philosophy begins with this refusal to be a matter of viewpoints. Its conception of itself includes transgressing and transcending the always reactive, often reactionary particularisms of an expression of opinion and the economies of interests. That is the philosophical universalism which is misrecognized as long as it is not comprehended that the power of this universalism is opposed to the power of relativism as an *assertion*, rather than as a *proof*, *opinion* or *ideal*, as a questioning of the certainty of proof or opinion. Philosophical universalism has nothing in its hands. It reaches for the ungraspable. And it defends this lack of property as its only possession. The subject of this lack of property is the subject of self-acceleration. Self-acceleration is a self-unbounding. The subject of self-acceleration comes into contact with the innocence, with the incommensurability and unliveability of life. The unliveability of life means its contingent character, its ontological arbitrariness. Only in the opening toward this arbitrariness is the subject free. When deceleration accelerates the subject beyond the coercion of acceleration in the sense of capitalist efficiency (that is, of a very restricted concept of efficiency lacking in courage), then this deceleration represents a form of self-acceleration that prevents the subject from bending to the demands of the economies of facts. That is the paradox of the experience of self-acceleration: that it reveals to the subject its freedom and its unfreedom to an equal extent. Because I am not free, I am free. In the space of my unfreedom, everything still remains to be done.

20. For every philosopher it holds that he (or she) brings forth his or her own concept of philosophy, just as every artist gives himself his own concept of art. The artist gives his (or her) concept of art through his or her work, which may include lectures and writings. The philosopher gives his concept of philosophy through his lectures, books, and writings. It is always a matter of inscribing oneself into an existing domain, into an already existing concept of art and

philosophy in order to question, in the critical engagement with the history of thinking, with the history of philosophy, this history, in order to risk one's own concept of philosophy. It is obvious that philosophy is not philosophy *about*.[5] There is an irreconcilable difference between the work of the historian of philosophy, whose necessity is indisputable, and the work of the philosopher. The philosopher's pretension lies in transcending the work on the history of philosophy, which is a part of his work, toward hazarding his own formulations, his own philosophical assertions. Philosophy as I understand it is not primarily an argumentative practice, an academic, theoretical, dialogical or historicizing procedure. It is never exhausted in commentary. It is never exhausted in recording the minutes of other thinkers' thinking.

21. It is obvious that art and philosophy exist only as a transgressing and surpassing of the narcissistic disposition. What is the subject of narcissism? The subject of narcissism is the subject that does not have the courage to decide because it senses or knows very well that a decision is not secured. There is no valid security for the decision. There is no one who could make the decision for me. The experience of decision is the experience of the ontological implausibility or ontological inconsistency of reality. Suddenly, I can no longer choose an alternative that goes back to the preceding decision of someone else; suddenly I find myself in that which could be called the *desert of freedom* where I go through the experience of a freedom, which is the experience of a valid lack of orientation. At the same time, this freedom and desert is the space in which decision, in which a certain autonomy of the human subject become possible. Art and philosophy are transgressions and transcendings of the narcissistic self-bracketing of the subject with its constituted reality.

22. The art work neither articulates its intimacy with nature and origins, nor does it make friends with the Zeitgeist. Art exists only as a conflict with its times and the reality of the Zeitgeist. Every genuine art work is out of time. It always comes too early, always from the future, never from the past. Bad art can be recognized through its sentimentality, nostalgia, adoration of the past, through its inability to make the future precise. Instead of competing with documentation and historical work, art is an opening toward the future. It is always a matter of tailoring names to the future today, of giving—today, here and now—a form to the formlessness of tomorrow. The defining task and mission of art includes the courage to give answers to questions which the future poses, to questions which do not preexist. There is no art beyond such an answer. There is no

art beyond the wager of bringing forth something new. However much the new relies on what already exists, it remains, as demanded by the Aristotelian perspective, nevertheless embedded in the material texture. The new redefines this texture, it rewrites it by appearing in it as something unforeseen, as something impossible.

23. Art does not come from a stable situation; it is the experience of the instability of the generally proclaimed and archived realities and evidence which are found to preexist and are continually reproduced. Art is affirmed experience of the porosity of the system of facts.[6] Therefore, for art there is no alliance with the facts; therefore it is a resistance against the facts, which does not mean that it misrecognizes the power and efficiency of assertions of fact. But art does not exhaust itself in demonstrating that it does not misrecognize, in its analytical power, which it also necessarily has. As long as art does not transcend and transgress its knowledge, it is not yet art. It would be nothing other than a form in which the subject achieves self-assurance within the fabric of its—critically or uncritically—commentated situation. Only an assertion of form that evades the sensibility of this self-assuring by articulating the transience of all certainties of fact succeeds in confronting the universal inconsistency which is the subject's proper time and its proper place.

5. Just as philosophy is not philosophy *about*, it is not philosophy *against*. In philosophy it is always a matter of transcending the *about* and the *against* toward a *for*. It is always a matter of thinking *for* something, that is, for the indeterminacy of that which does not (yet) exist. Cf. Gilles Deleuze, *Woran erkennt man den Strukturalismus?* Berlin, 1992, p. 60

> No book against something, no matter what it is, is ever significant: only those books 'for' something new count, and those that know how to produce it.

6. "The characteristic feature of the archive is its gap, its perforated essence," writes Didi-Huberman. Doesn't this mean that the archive itself *is* the gap, the crack in presence? See Georges Didi-Huberman, "Das Archiv brennt," in Didi-Huberman/Knut Ebeling, *Das Archiv brennt*, Berlin, 2007, p. 7.

Notes:

1. Heiner Müller, *Gespräche 1*, Werke 10, Frankfurt-am-Main, 2008, p. 598.

2. Giorgio Agamben, *Die Sprache und der Tod: Ein Seminar über den Ort der Negativität*, Frankfurt-am-Main, 2007.

3. The human being is "not at home in its own essence," says Heidegger (*Einführung in die Metaphysik*, Tübingen 1987, p. 120); therefore in Deleuze's and Derrida's thinking it is not called a *subject*. The subject is too late, too early or delayed relative to itself, "always belated and premature, in both directions simultaneously, but never on time," says Deleuze (*Logik des Sinns*, Frankfurt-am-Main, 1993, p. 107). It is the subject of absolute non-simultaneity, subject of a certain *différence* (Derrida), of an irreducible deferment and conflict. It does not coincide with itself, does not agree with itself, is alien vis-à-vis itself. It is scarcely still a subject insofar as we understand by that the transcendental self-conscious subject of thinking in the modern age, Descartes' *fundamentum inconcussum*, Kant's transcendental subject, the concept that conceives itself of Hegelian and German idealism in general. As a subject of an original, not subsequent (self-)alienation, it is a subject without any transcendental housing, a subject without subjectivity because its subjectivity is the name of this *without*.

4 Hans Blumenberg, *Theorie der Unbegrifflichkeit*, Frankfurt-am-Main, 2007, p. 17.

Marcus Steinweg, born in 1971, Philosopher. His recent books are "Behauptungsphilosophie", Berlin 2006, and "Duras" (with Rosemarie Trockel), Berlin 2008. Forthcoming: "Maps" (with Thomas Hirschhorn), Berlin 2009.

23 Thesen zu Kunst, Philosophie, Wahrheit und Subjektivität

1. Kunst & Philosophie sind Wahrheitsberührungen, solange wir unter Wahrheit verstehen, was nicht existiert.

2. Ich nenne Wahrheit, was jegliches Wissen, jegliche Meinung, jegliche Realität als Inkonsistenz heimsucht, um die Stabilität jeder Wissens-, Meinungs- und Realitätskonstruktion zu bedrohen.

3. Zur Wahrheit gehört, dass sie nicht vorliegt wie etwas Seiendes. Wahrheit hat keinerlei ontologische Positivität. Und doch verbindet Kunst & Philosophie die Öffnung auf diese Dimension der Nicht-Positivität und Inkonsistenz, die ich Wahrheit nenne oder Inkommensurabilität. Kunst & Philosophie weigern sich, sich mit der Realität in ihrem Gegebenheitsstatus zu arrangieren. Deshalb erstrecken sie sich auf Wahrheit, weil diese Erstreckung heisst, die Realität mit ihrer Wahrheit als der ihr impliziten Inkommensurabilität zu konfrontieren.

4. Realität nenne ich die Welt, wie sie ist und erscheint: Welt der Möglichkeiten, der Kommunikation, der zirkulierenden Werte, Gesetze und Regeln. Materielle wie spirituelle Welt kollektiver Phantasien, Ängste und Hoffnungen. Kosmos kriegerischer, sentimentaler, ökonomischer Konflikte. Welt voller Bilder, Welt der Sprache, der Information und Kritik. Historische Welt, heterogenes Feld kultureller, lokaler, geopolitischer Differenzen. Konsistenzraum oder Vertrautheitsuniversum, in dem sich—trotz allem—leben lässt.

5. Wahrheit ist, was eine gewisse Unlebbarkeit in diesen Lebbarkeitsraum einträgt. Wahrheit ist der Name der Unterbrechung des Möglichkeitssystems. Eine Wahrheit zu berühren bedeutet, mit dem Unmöglichen in Kontakt zu treten. Mit dem Unmöglichen wie mit dem nicht weiter Kommunizierbaren, mit dem Jenseits der Information und mit dem Jenseits der Sprache. Mit dem also, was sich nur als Widerstand im Hier und Jetzt der einen Welt erfahren lässt. Wahrheit ist also der Name dessen, was resistiert.

6. Es gibt nur eine Welt, es gibt keine zweite: Keine Hinterwelt, keinen utopischen Ort. Aber diese eine Welt ohne Ausgang ist in keinem Fall identisch mit ihren bildhaften, informationellen, sprachlichen Repräsentanzen. Vielmehr eignet ihr eine Inkommensurabilität, die sich ihrer direkten Apparenz verweigert. Sie benennt nichts als die Inkonsistenz dieses Konsistenzuniversums, das wir Wirklichkeit nennen.

7. Mit der Wahrheit meldet sich eine elementare Unvertrautheit, die zur Vertrautheitsschicht, die unsere Welt ist, ursprünglich gehört.

8. Kunst & Philosophie rühren an diese Unvertrautheit, um auf eine Instabilität oder Indifferenz zu zeigen, die alle Sinn- und Werkkonstruktionen ihrer ontologischen Ungesichertheit überführt. Hier liegt die kritische Kraft von Kunst & Philosophie: in diesem Zeigen auf den irreduziblen Nichtsinn, der die Wahrheit aller Bedeutungsarchitekturen und Sinnprozeduren bleibt.

9. Sinn und Bedeutung sind Erfindungen, deren Glaubwürdigkeit sich am Grad ihrer Öffnung auf die Dimension des Nichtsinns, d.h. der Wahrheit, bemisst. Nur der Sinn, der den Kontakt zum Nichtsinn, nur die Bedeutung, die die Intimität mit dem Bedeutungslosen, aufrecht erhalten, sind von künstlerischer oder philosophischer Relevanz.

10. Nur die Kunst ist glaubwürdig, die den Mut zu dieser Öffnung auf das Inkommensurable hat. Die Formbehauptungen der Kunst sind solche Mutproben, sdie die Weigerung sich mit den anerkannten Realitäten zu arrangieren als ihre Bedingung affirmieren.

11. Kunst und Philosophie sind Selbsterhebungspraktiken im Hier und Jetzt der einen Realität. Nur in der Auseinandersetzung mit den Dispositiven und Funktionsweisen der Welt in ihrer aktuellen Form, kann ihr ein Widerstand eingetragen werden, der den Abstand zwischen der Selbstinterpretation dieser Dispositive und Funktionen einerseits und der von ihnen geleugneten, verdrängten und ignorierten inkommensurablen Anteile artikuliert. Es gibt keine Kunst, die sich dieser Artikulation, so implizit sie geschehen mag, entziehen könnte. Denn erst der Abstand zur Realität gibt dem Kunstwerk seine von ihr distante Gestalt.

12. Distanz ist Bedingung der Möglichkeit jeder künstlerischen Artikulation, die der Versuchung zur Assimilation an das Bestehende widersteht. Ich nenne die Welt des Bestehenden Realität oder Tatsachenwelt. Zur Tatsache gehört, dass sie ihre Inkonsistenz leugnet. Die Insistenz auf Tatsachen hat regelmässig diese Funktion: eine Wahrheitsberührung auszuschliessen, indem sie auf ihre Unmöglichkeit verweist. Der Tatsachensinn ist der Bruder des gesunden Menschenverstands.

13. Was der Tatsachensinn zu verschleiern versucht, ist, dass jede Gewissheit, alle Evidenzen über dem Abgrund einer Wahrheit schweben, die nicht existiert. Der Tatsachensinn hat die Funktion den notwendig riskanten Kontakt mit diesem Abgrund zu verhindern, indem er nicht aufhört die ontologische Effizienz dessen zu bestreiten, was nicht existiert. Dass etwas nicht existiert bedeutet nicht, dass es wirkungslos bliebe. Genau genommen ist eine Wahrheit oder das Nichts von unerbittlicher Effizienz. Wenn wir die Wahrheit mit dem Inkommensurablen gleichsetzen, dann kann man zwar behaupten, dass es Subjekte gibt, die sich um die Wahrheit nicht scheren. Wahrheit dagegen gibt es nur als dasjenige, was kein Subjekt vergisst. Gottfried Benn hat auf dieser Effizienz bestanden, indem er, wie Heiner Müller erinnert, die Kunst als eine „Leistung gegen den Nihilismus" begreift.[1] Dass es Nichts gibt, bedeutet schlicht, dass die Realität nicht alles ist, so sehr sie die einzige bleibt. Alles was zählt in der Kunst und in der Philosophie öffnet sich dem Nichts, indem es sich weigert, sich ihm zu opfern. Immer geht es darum, einen infinitesimalen Abstand zum Nichts, zur Wahrheit, zum Inkommensurablen zu formulieren. Den aktiven Nihilismus der Wahrheitsberührung unterscheidet vom passiven Nihilismus der Wahrheitsverweigerung, dass er einen minimalen Widerstand gegenüber dem Inkommensurablen artikuliert. Das Problem von Kunst & Philosophie wird nie etwas anderes sein als der Versuch, sich auf der Höhe des Nichts, auf Augenhöhe mit dem Abgrund der Wahrheit zu bewegen.

14. Das ist die fundamentale Erfahrung von Kunst & Philosophie: dieser Kontakt auf Augenhöhe mit dem, was das Denken mit Blindheit schlägt. Es gibt eine Wahrheitsberührung nur als Erfahrung dieser Blindheit, die das Subjekt vom Diktat des Wissens, der Kontrolle, des Eigentums emanzipiert. Es gibt keine Kunst und keine Philosophie jenseits des Wissens und einer gewissen Verständigkeit, nur arbeitet in diesem Wissen und im Verstehen bereits eine Blindheit und ein Nichtverstehen, die das Denken von Kunst & Philosophie auf das Jenseits ihrer Möglichkeiten treibt. Man denkt nicht, solange man denkt, dass Denken zunächst ein kritischer Akt ist, Analyse, reflexive Intelligenz. Jeder Kritik, jeder Analyse, jeder Reflexion ist eine Bejahung implizit, die den Kontakt zum Unwissbaren hält. Immer bewegt sich das Denken auf das Undenkbare zu, auf die Totalität dessen, was seinen Kategorien entweicht. Hier beginnt erst Denken: am Limes seiner Unmöglichkeit, als Beschleunigung über die etablierten Evidenzen hinaus, als rückhaltlose Bejahung all dessen, was man nicht versteht, und einem derart zu denken gibt. Sich auf der Höhe des Nichts zu bewegen, bedeutet deshalb auf der Höhe seiner Schwächen, seines Unvermögens zu denken, statt sich der Illusion alles kontrollierenden Wissens hinzugeben. Zur Wahrheitsberührung gehört die Öffnung des Subjekts auf sein Aussen, das es selbst nicht besitzt, nicht unter Kontrolle bringen kann. Das Subjekt von Kunst & Philosophie ist in diesem Sinn auf seine Inkommensurabilität entsichertes Subjekt.

15. Denken ist entsichertes Denken oder gar nicht. Die Reproduktion, die jedem Denken angehört, die Neuverteilung des Materials, der Ideen und Konzepte, ihre Fragmentisierung und Konnexion mit scheinbar gänzlich Anderem, muss sich der Chance des Neuen öffnen, das notwendig als Chaos, als Unordnung erscheint. Die Selbstentsicherung des Subjekts auf das Neue gehört ihm per definitionem an. Es gibt so etwas wie ein Subjekt nur als originäre Selbstverfehlung, als Selbstüberschrittenheit von Anfang an. Statt Produkt einer narzisstischen Selbsteinschliessung zu sein — als Selbstbewusstsein etc. — erfährt sich das Subjekt als ursprüngliche Exteriorität auf die Sphären des Nichtsinns, der Andersheit, des Unmöglichen. Die Entsicherung auf diesen Bereich ist keine nachträgliche. Vielmehr ist das Subjekt immer schon bezogen auf etwas, was ihm angehört, indem es sich ihm entzieht. In diesem Entzug bleiben alle seine Akte und Entscheidungen gehalten. Bezogen auf eine Leere, eine Absenz, ein Loch im Sein. Bezogen also auf eine Alterität, die sich als Unvertrautheit oder Unheimlichkeit meldet, um das Subjekt immer wieder aus dem Tritt kommen zu lassen, während sie es mit der Kontingenz und Unabgeschlossenheit seiner Realität konfrontiert.

16. Es ist diese Unabgeschlossenheit, die zur Sorge des Denkens geworden ist, diese Ruhelosigkeit im Sein, diese expansive Kraft, die wie ein blinder Vektor noch die entschiedensten, die am meisten rationalen Akte des Subjekts auf eine Inkommensurabilität beziehen, die die Macht des Verstands, der Ratio wie jeglichen Kalküls, a priori beschränkt. Der Raum dieser Beschränkung bleibt der Lebensraum, die einzige Realität, des Subjekts. Hier artikuliert es seine Hoffnungen und Ängste, im Hier und Jetzt einer irreduziblen Unübersichtlichkeit. Deshalb macht es Sinn diese Realität als Dimension einer gewissen Blindheit zu affirmieren, in der dem Subjekts nichts übrig bleibt als *dennoch* zu entscheiden, *dennoch* zu handeln, *dennoch* zu leben, da doch seine Entscheidungen im Unentscheidbaren getroffen werden müssen, und seine Handlungen es vor seine Grenzen stellen, und seine Lebensform auf das Unlebbare geöffnet bleibt.

17. Zum Denken in Begriffen, gehört die Erstreckung auf das Ausserbegriffliche, auf die implizite Unmöglichkeit begrifflicher Seins- und Welterfassung. Der Begriff grenzt an den Bereich des Nichtbegrifflichen. Es gibt ihn nur in Form dieser Grenzberührung, als Überschreitung oder Exzess, als Aussersichsein einer Form, die sich nicht länger der Formlosigkeit der präbegrifflichen Entitäten verschliesst. Die Dimension des Präbegrifflichen kann als Ordnung der präsynthetischen Spur, als Bereich des *gramma* (Derrida) oder, in der Terminologie Agambens, der Stimme, bezeichnet werden, als die Dimension einer Differenz und Grenze, die sich dem begrifflichen Begehren als Widerstand zeigt.[2] Ich nenne diesen Raum den Bereich des Inkommensurablen, wobei es unerlässlich wird darauf zu insistieren, dass das Inkommensurable kein sublimes Jenseits meint, sondern diesen Spalt im Begriff selbst, die Differenz in der Identität markiert. Eine Differenz, die das identifizierende Denken von seinen Anfängen her nicht aufhört heimzusuchen. Es ist diese Präsenz der Differenz im Präsenzdenken, das Metaphysik heisst, die die einfache Unterscheidung des metaphysischen vom transmetaphysischen (dekonstruktiven etc.) Denken, wie Derrida selbst sagen würde, unendlich verkompliziert. *Unendlich*, im Sinne des von Blanchot verteidigten Sinns von Unendlichkeit, der auf die Unabschliessbarkeit und Unaufhörlichkeit zielt. Kompliziert, im Sinne der Unmöglichkeit einer befriedigenden Befriedung des begrifflichen Denkens in Binärmustern. Das Verhältnis von Präsenz und Absenz, Identität und Differenz, Begriff und Nichtbegrifflichem, wird sich keiner hierarchischen Struktur beugen, die das eine Element, umwillen seiner Klassifizierung, dem anderen Element unterordnet, ihm also eine Art begrifflicher Ungerechtigkeit widerfahren lässt.

Zu dieser begrifflichen Ungerechtigkeit, zur *Ungerechtigkeit des Begriffs*, haben Adorno und Derrida (wie viele andere) das Notwendigste gesagt. Agamben wiederum besteht zu Recht darauf, dass das *Metaphysik* genannte Denken, statt schlicht der Name dieser Ungerechtigkeit zu sein, ihr nicht selbst geopfert werden kann, da es doch selbst komplizierter oder komplexer ist als es die Ungerechtigkeit will. Zum metaphysischen Denken gehört bereits diese Selbstverlängerung des Begriffs auf seinen dunklen Grund, den Agamben als Abgrund der Negativität beschreibt.

18. Das abendländische Denken lebt von der Illusion der Identität und Selbstgleichheit des menschlichen Subjekts. Immer geht es ihm um die Frage „Wer bin ich?". Immer wird diese Frage beantwortet, indem man dem Ich ein Zuhause verspricht, eine transzendentale Intimität und Selbstvertrautheit mit sich. Und dennoch ist klar: dass dieser Wille und dieses Begehren und die Ethik, die eine solche Selbststabilisierung in einer Ich- oder Selbst-Entität fordert, sich der ontologischen Katastrophe verdankt: der Ahnung, dem Wissen, dass es kein mit sich identisches Subjekt gibt. Vielleicht gibt es so etwas, wie ein Subjekt: nur stimmt es nicht mit sich überein.[3] Philosophie hält sich so entfernt wie möglich vom Phantasma des Selbstbesitzes, von der Illusion der vollen Rede, die den Logos der Tatsachengewissheiten oder *doxai* beherrscht. Es gibt Philosophie nur, solange sie sich diesem Phantasma und dieser Illusion des Selbstbesitzes sperrt, solange sie eine Bewegung primordialer Selbstenteignung anerkennt, solange sie begreift, dass der Nicht-Logos oder Ante-Logos bereits im Herzen des Logos wohnt. Der Logos ist Geöffnetheit auf das Chaos, das Logossubjekt nur *bei sich*, indem es *ausser sich* ist, *über sich hinaus*. Das ist der implizite Wahnsinn des Logos, sein Hyperbolismus, dass er nur als Berührung seiner Grenzen existiert: „Der Mensch", schreibt Hans Blumenberg, „ist seinem Ursprung nach an das Prinzip der Überflüssigkeit, des Luxus gebunden. Der aufrechte Gang ist vom ersten Augenblick an luxurierend: zu sehen, was noch nicht gegenwärtig ist, was *noch keine akute Notwendigkeit* besitzt, Prävention zu üben in bezug auf das, was nur unleibhaftige Möglichkeit, potentielle Drohung oder Lockung ist, das ist immer eine Sache des zu grossen Aufwandes und nicht zufällig darin ebenso aller *Aggressionen* Anfang wie die Möglichkeit ihres Endes."[4] Zum Logossubjekt gehört dieser Überfluss, diese Übertreibung, dieses Zuviel, diese Transzendenz seiner augenblicklichen Situation.

19. Die Philosophie kennt ihre eigene Geschwindigkeit. Manchmal liegt ihre Beschleunigung in der Zurückhaltung,

in einer gewissen Abstinenz im Verhältnis zu den *Problemen der Zeit*. Manchmal beschleunigt die Philosophie, indem sie verlangsamt, indem sie sich entschleunigt oder sich tot stellt. Die Gewalt der Philosophie liegt in dieser Beschleunigung, die etwas anderes als das Gegenteil der Entschleunigung ist. Die Selbstbeschleunigung der Philosophie meint ihre Öffnung auf die Dimension des Unentschiedenen, der Zukunft, der Kontingenz. Die Selbstbejahung des philosophischen Subjekts als Subjekt dieser Öffnung ist eine notwendig überstürzte Affirmation. Das Subjekt bejaht, was es nicht kennt. Die Selbstbeschleunigung der Philosophie ist eine solche Überstürzung. Wer behauptet, dass es Überstürzung nicht auch als Abstinenz von ihrer Zeit gibt, als Diskretion vom Zeitgeist, solange seine Beschleunigungszwänge der Fixierung der etablierten Realitäten zuarbeiten? Es gibt Philosophie nur als Behauptungsphilosophie. Eine Behauptung ist immer zu schnell, immer überhastet, immer übertrieben und kopflos. Und dennoch kennt die philosophische Behauptung ihre eigene Präzision. Philosophie ist eine Lebensform, die das Subjekt über seine Gewissheiten hinwegreisst. Das Subjekt der Philosophie beschleunigt über seine objektive Realität im etablierten Realitätsfeld hinaus. Es bejaht sich als Autorität von Handlungen, die es nicht mehr kontrolliert. Die Zeiterfahrung der Philosophie ist Erfahrung dieser Kontrolllosigkeit, Erfahrung der Fragilität, der ontologischen Unbestimmtheit, d.h. der Konstruiertheit, des fiktionalen Status' ihrer Zeit und Realität. Zu keinem Zeitpunkt in der Geschichte der Philosophie ging es der Philosophie darum „Ansichten über die Zeit" zu formulieren. Die Philosophie beginnt mit dieser Weigerung, Ansichtssache zu sein. Zu ihrem Selbstverständnis gehört die Überschreitung der immer reaktiven, oft reaktionären, Partikularismen der Meinungsäusserung und Interessensökonomien. Das ist der philosophische Universalismus, den man verkennt, solange man nicht begreift, dass die Gewalt dieses Universalismus' sich der Gewalt des Relativismus als *Behauptung*, statt als *Beweis* oder *Meinung* oder *Ideal* entgegenstellt. Als Befragung der Beweis- und der Meinungsgewissheit. Der philosophische Universalismus hat nichts in der Hand. Er greift nach dem Ungreifbaren. Und er verteidigt diese Eigentumslosigkeit als seinen einzigen Besitz. Das Subjekt der Eigentumslosigkeit ist Subjekt der Selbstbeschleunigung. Selbstbeschleunigung ist Selbstentgrenzung. Das Subjekt der Selbstbeschleunigung tritt mit der Unschuld, mit der Inkommensurabilität und Unlebbarkeit des Lebens in Kontakt. Die Unlebbarkeit des Lebens meint seinen Kontingenzcharakter, seine ontologische Arbitrarität. In der Öffnung auf diese Arbitrarität ist das Subjekt erst frei. Wenn die Entschleunigung das Subjekt

über den Zwang zur Beschleunigung im Sinne kapitalistischer Effizienz (also eines sehr mutlosen, sehr beschränkten Begriffs von Effizienz) hinausbeschleunigt, dann könnte diese Entschleunigung eine Form der Selbstbeschleunigung darstellen, die verhindert, dass das Subjekt sich den Forderungen der Tatsachenökonomie beugt. Das ist das Paradox der Erfahrung der Selbstbeschleunigung: dass sie dem Subjekt seine Freiheit und Unfreiheit gleichermassen enthüllt. Weil ich nicht frei bin, bin ich frei. Im Raum meiner Unfreiheit bleibt noch alles zu tun.

20. Für jeden Philosophen gilt, dass er seinen eigenen Begriff von Philosophie hervorbringt, so wie jeder Künstler seinen eigenen Begriff von Kunst gibt. Der Künstler gibt seinen Begriff von Kunst durch seine Arbeit, die Vorträge und Texte einschliessen kann. Der Philosoph gibt seinen Begriff von Philosophie durch seine Vorträge, Bücher und Texte. Immer geht es darum, sich nicht in ein bestehendes Feld, in einen schon existierenden Begriff von Kunst und Philosophie einzuschreiben, um in der Auseinandersetzung mit der Geschichte des Denkens, mit der Geschichte der Philosophie diese Geschichte zu befragen, um einen eigenen Begriff von Philosophie zu riskieren. Es ist klar, dass Philosophie nicht Philosophie *über* ist.[5] Es gibt einen unversöhnlichen Unterschied zwischen der Arbeit des Philosophiehistorikers (deren Notwendigkeit unbestreitbar ist) und derjenigen des Philosophen. Der Anspruch des Philosophen liegt darin, die philosophiehistorische Arbeit—die einen Teil seiner Arbeit ausmacht—auf das Wagnis eigener Formulierungen hin zu überschreiten, eigener philosophischer Behauptungen. Philosophie, wie ich sie verstehe, ist nicht primär eine argumentative Praxis, eine akademische, theoretische, dialogische oder historisierende Prozedur. Nie erschöpft sie sich im Kommentar. Nie erschöpft sie sich darin, das Denken anderer Denker zu protokollieren.

21. Es ist klar, dass es Kunst und Philosophie nur als Überschreitung der narzisstischen Disposition gibt. Was ist das Subjekt des Narzissmus? Das Subjekt des Narzissmus ist das Subjekt, das den Mut der Entscheidung nicht hat, weil es sehr genau ahnt oder weiss, dass eine Entscheidung nicht gesichert ist. Es gibt keine gültige Sicherung der Entscheidung. Es gibt niemanden, der mir die Entscheidung abnimmt. Die Erfahrung der Entscheidung ist die Erfahrung der ontologischen Nichtplausibilität oder ontologischen Inkonsistenz der Realität. Plötzlich kann ich nicht mehr eine Alternative wählen, die auf eine Vorentscheidung eines Anderen zurückgeht, plötzlich befinde ich mich in dem, was man die *Wüste der Freiheit* nennen könnte, mache ich die

Erfahrung einer Freiheit, die Erfahrung gültiger Orientierungslosigkeit ist. Gleichzeitig ist diese Freiheit und Wüste der Raum, in dem Entscheidung, in dem eine gewisse Autonomie des menschlichen Subjekts möglich werden. Kunst und Philosophie sind Überschreitungen der narzisstischen Selbstverklammerung des Subjekts mit seiner konstituierten Realität.

22. Weder artikuliert das Kunstwerk seine Intimität mit der Natur und den Ursprüngen, noch befreundet es sich mit dem Zeitgeist. Es gibt Kunst nur als Konflikt mit ihrer Zeit und der Zeitgeistrealität. Jedes echte Kunstwerk ist unzeitgemäss. Es kommt immer zu früh, immer aus der Zukunft, nie aus der Vergangenheit. Schlechte Kunst erkennt man an Sentimentalität, Nostalgie, Vergangenheitsanbetung, an ihrer Unfähigkeit die Zukunft zu präzisieren. Statt mit der Dokumentation und historischen Arbeit zu konkurrieren, ist Kunst Öffnung auf Zukunft. Immer geht es darum, dem Künftigen Namen anzumessen, der Formlosigkeit des Morgen heute—hier und jetzt—eine Form zu geben. Zum definitorischen Auftrag von Kunst gehört der Mut, Antworten zu geben auf Fragen, die die Zukunft stellt, auf Fragen, die nicht präexistieren. Es gibt keine Kunst jenseits einer solchen Antwort. Es gibt keine Kunst jenseits des Wagnis' der Hervorbringung von etwas Neuem. Sosehr das Neue auf Bestehendes verwiesen ist, sosehr es—wie es die aristotelische Perspektive verlangt—eingebettet bleibt in die materielle Textur, so sehr definiert das Neue diese Textur um, so sehr schreibt es sie neu, indem es in ihr als nicht Vorgesehenes, als Unmögliches erscheint.

23. Kunst kommt nicht aus der stabilen Lage, sie ist Erfahrung der Instabilität der vorgefundenen, kontinuell reproduzierten, allgemein proklamierten und archivierten Realitäten und Evidenzen. Kunst ist die affirmierte Erfahrung der Löchrigkeit des Tatsachensystems.[6] Deshalb gibt es für die Kunst keine Allianz mit den Tatsachen, deshalb ist sie Tatsachenresistenz, was nicht heisst, dass sie die Macht und Effizienz der Tatsachenbehauptungen verkennt. Nur erschöpft sich Kunst nicht in der Demonstration dieser Nichtverkennung, in der analytischen Kraft, die ihr notwendig angehört. Solange die Kunst nicht ihr Wissen überschreitet, ist sie keine Kunst. Sie wäre nichts als eine Form der Selbstversicherung des Subjekts im Gewebe seiner—kritisch oder nicht—kommentierten Lage. Erst der Formbehauptung, die der Sensibilität dieser Selbstversicherung entgeht, indem sie die Flüchtigkeit aller Tatsachengewissheiten artikuliert, gelingt die Konfrontation mit der universellen Inkonsistenz, die die eigentliche Zeit und der eigentliche Ort des Subjekts ist.

Notes:

1. Heiner Müller, *Gespräche 1*, Werke 10, Frankfurt a. M. 2008, S. 598.
2. Giorgio Agamben, *Die Sprache und der Tod. Ein Seminar über den Ort der Negativität*, Frankfurt a. M. 2007.

3. Der Mensch sei "in seinem eigenen Wesen unheimisch", so Heidegger (*Einführung in die Metaphysik*, Tübingen 1987, S. 120), deshalb heisst er u.a. bei Deleuze und Derrida nicht "Subjekt". Das Subjekt ist verspätet, verfrüht, oder verzögert zu sich: "immer verspätet und vorzeitig, in beide Richtungen zugleich, aber niemals rechtzeitig", sagt Deleuze (*Logik des Sinns*, Frankfurt a. M. 1993, S. 107). Es ist Subjekt der absoluten Ungleichzeitigkeit, Subjekt einer gewissen *différance*, (Derrida), eines irreduziblen Aufschubs und Widerstreits: Es deckt sich nicht mit sich. Es kommt mit sich nicht überein, ist sich selbst gegenüber fremd. Er ist kaum noch ein Subjekt, sofern man darunter das transzendentale Selbstbewusstseins-Subjekt des neuzeitlichen Denkens versteht, das *fundamentum inconcussum* Descartes', das transzendentale Subjekt Kants, den sich selbst begreifenden Begriff Hegels und des deutschen Idealismus im allgemeinen. Das Subjekt der ursprünglichen, nicht-nachträglichen (Selbst-)Entfremdung ist ein Subjekt ohne transzendentale Unterkunft: Subjekt der "transzendentalen Obdachlosigkeit", Subjekt ohne Subjektivität, da seine Subjektivität der Name dieses *ohne* ist.

4. Hans Blumenberg, *Theorie der Unbegrifflichkeit*, Frankfurt a. M. 2007, S. 17.

5. So, wie die Philosophie nicht Philosophie *über* ist, ist sie nicht Philosophie *gegen*. Immer geht es in der Philosophie um die Überschreitung des *Über* und des *Gegen* auf ein *Für* hin. Immer geht es darum, für etwas zu denken, das heisst für die Unbestimmtheit dessen, was (noch) nicht existiert. Vgl. hierzu Gilles Deleuze, *Woran erkennt man den Strukturalismus?*, Berlin 1992, S. 60: "Kein Buch gegen etwas, was dies auch immer sei, hat jemals Bedeutung; es zählen allein die Bücher ‚für' etwas Neues, und die Bücher, die es zu produzieren wissen."

6. "Das Eigentliche des Archivs ist seine Lücke, sein durchlöchertes Wesen", schreibt Didi-Huberman. Heisst das nicht: das Archiv selbst *ist* die Lücke, der Spalt in der Präsenz? Vgl. Georges Didi-Huberman "Das Archiv brennt", in: ders. / Knut Ebeling, *Das Archiv brennt*, Berlin 2007, S. 7.

Marcus Steinweg, geboren 1971, Philosoph. Seine letzten Bücher sind "Behauptungsphilosophie", Berlin 2006, und "Duras" (mit Rosemarie Trockel), Berlin 2008. Im Erscheinen: "Maps" (mit Thomas Hirschhorn), Berlin 2009.

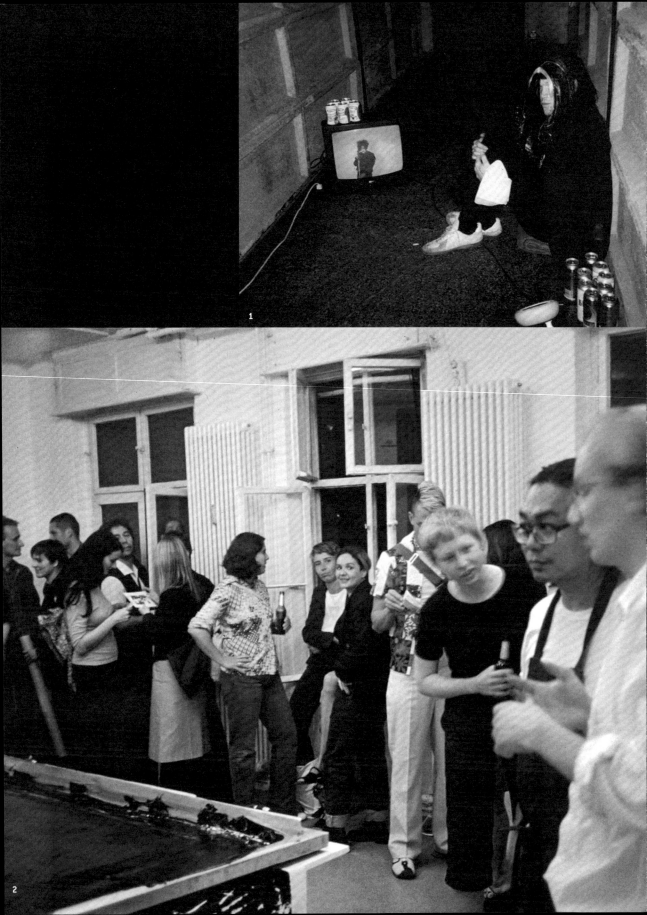

1

2

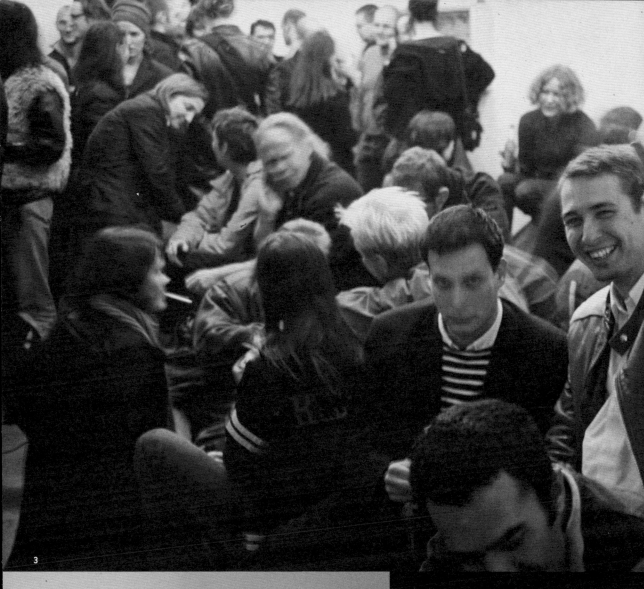

3

4

1. *FAT ROB/SLIM ROB*
Performance by Diego Castro the founder of
BergstüblPROJEKTE, 2000.

2. *Berühmte Künstler helfen Koch und Kesslau*
Opening reception for the group exhibition at Koch und
Kesslau, 2000. In the foreground are Rirkrit Tiravanija
and Andreas Koch.

3. Koch und Kesslau
Opening reception for the exhibition *Stefan Beuchel*, 2000.
In the foreground are Gregor Hildebrandt and René Lück.

4. BergstüblPROJEKTE
Exhibition space located on Veteranenstraße above the
Bergstübl bar and run by Diego Castro, Ingo Gerken and
Stephan Kallage from 2000 to 2004. *Stretched Impact
(Neue Nationalgalerie)*, 2002 by Ingo Gerken is shown.

Ego sums

There's nothing better than good teamwork. You don't always have to argue only with yourself. That's not to be underestimated. When two people in the same room have the same idea and find it good, that usually makes it better.

If here we are to speak about possible interactions between individual artistic existence and changing group identities in a single person, it's hard to say whether the one is helpful for the other, or even a precondition, if both have been practiced in parallel over several years. Multifaceted identities are helpful sometimes, not just in committing insurance fraud. Now and again, however, it's not a bad thing, when you get up in the morning, to clarify whether you will end this day in an individual or a group bond. A proportionality between scattering oneself and mutual stimulation can scarcely be evaluated according to an efficiency factor. Like most state-socialized artist careers, I too have spent too much time in one of these academies of the arts. But even there, the rather indirect form of cooperation working next to one another in one and the same (class)room over one or two semesters can trigger mimetic processes even after a long time. You do this or that surprising thing for yourself and suddenly, ten minutes or ten days later, you notice that you have now been able to incorporate the paint-splattering trick or the argumentation loop of Michael or Babs into your own working apparatus. If I had to believe in something in connection with learning techniques, then it would have to be in mimesis. Assuming that you are inclined to try various things out, it is also helpful to use the various working contexts as different rehearsal stages. What in an artist's late work perhaps goes off too much at a tangent, fits well as a contribution to an appropriate project. A certain way of drawing would not have occurred to me if I had not for a time made a journal by the name of *Dank* together with some friends and colleagues. Furthermore, the multitude of immediate reactions fed back in teamwork is helpful as a sounding board. Even though after some collaboration you are able to roughly assess the patterns of taste in each case, surprising judgments crop up here, too, which can sensibly confuse your own overly fixed techniques of opinion and criteria systems.

If over the long term you assume several roles, behaviors or even identities (criticism, art, curating) in the culture industry, it is advantageous to keep a sense of proportion in mind when hopping from one role to the other. If one role becomes too present in one working context, you'll have to strengthen the other vocational strand. Otherwise, in a certain public perception, you'll be identified only with the one activity. If the one functional ascription has been consolidated on all sides, quite a few stones have to be shifted until, for instance, the label of crude hack writer, who also draws, or vice versa, can be detached once again. To this extent, a very sensitive positioning technique is required, as when you select the right color tone in the right place in the right painting, but coded in another way. Sometimes, when meeting new people, it happens that your interlocutor may be curious about or familiar with only *one* type of action, which can be clarified as it suits you. Of course, the question whether you are perhaps making things unnecessarily difficult for yourself arises. It is already difficult enough to get the world of multipliers interested in a single project or a completed work for more than ten seconds.

If someone tells me they do art, curate exhibitions, and write art criticism, I don't necessarily take them any more seriously. You don't always have to presume a weakness of concentration, but not multiple talents either. Whether you are suited to two different roles can be easily ascertained. You have to be able to drum both hands on the table in different beats and to keep the different rhythms. Often it is not a bad thing when the one hand does not know what the other hand is doing. One reason for keeping distant from positions which play parallel, functionally different roles within the culture industry may not only be for purposes of transparency, but also

because activities are identified with social functions and, moreover, with identities. Someone who crops up every three days with a new face but the same name is hard to recognize. Often we have problems even in remembering the right name for each person's face. If, in addition, you have to assign three functions to one pair of eyes and evaluate them, you almost get slightly annoyed: this person's demanding an awful lot of attention. At any one time you have only one favorite song, but even if you have two, you can only listen to one at one time. From a commercial standpoint, the matter is considerably simpler: the newly slaughtered cow, which itself makes the food and sets the price, is viewed with mistrust.

Despite this, of course, it is implausible that a rigid structure of competencies should not experience enlivening stimulation precisely through hybrid role-twisting. In the case of a piece of writing, this can happen as follows: write an article that also works as a review, but does not fulfill any of the formal conditions of the article format and, furthermore, allows practical competence to shine through, but without fabricating one of those lyrically muddled artist's texts. What will probably come out is a delicately verbalized interior form between the one and the other.

Just as the genres of written texts can be used in a redefined or de-defined way, similar ambitions are conceivable also within the general structures of the culture industry through a change of competencies, assuming that you are in a position to place sustained accents on each of the different functions. Of course, this is merely conceivable, which does not mean that in the microcosm of your neighborhood you could not realize other appropriate structures. If you like, you can call these ways of proceeding micropolitical. It is obvious that an industry, if, as in the case of art, it lives largely from being paired with contingency and undefined factors, would like to project the appearance of something well-defined, at least within the social framework of its industrial interior by strictly and rigidly distributing roles. This, however, does not have to alter the circumstance that things need to be changed. If McKinsey were employed to investigate the general economic system of art as one industrial sector, he would probably come to the commercial recommendation that it would be better not to rely on such an intransparent number of financial sources. The more sensitively a system reacts to even small tendencies to change, the greater the probability of a reform backlog.

It's pretty futile to look for the ideological wingspan between these individual and group ways of production. Of course, they continue to hover around diffusely, although much less infused with ideology than a few years ago. The spectrum of opinion, in a superfluously polarized form, sounds roughly like this: the elevated individual artist is an antiquated role model of the century before last, or the deserving collective power needs the productive herd too much as its existential, working conditions. If you cannot be a stone, then be the mortise in between. Brought up to date somewhat, these cornerstone opinions sound like this: the cult of genius of the nineteenth century has been modernized in the direction of the pop-star system, and the collective ideological power of the blinkered, single-minded, left-wing German has found its neo-liberal counterpart in dot-com power which, over-identified with and disillusioned by envisioned shallow hierarchies, is now allowed to reflect on its unfettered release.

There is a somewhat peculiar circumstance called symbolic capital. This is not so much a substitute currency, but rather a diffuse valuation system nominally directed toward the outside, but negotiated internally, whereby "internal," of course, is only relative. Symbolic capital maintains a certain cultural achievement that has attained tendentially widespread regard. Widespread means generating, as far as possible, consensus even among opinionmakers who otherwise tend to be opposed. That's it; it sounds like an honorary position. Symbolic capital is, so to speak, virtually tacked onto the body of those with a vague promise, according to the principle that the person who causes damage must bear the cost. That is, people acknowledge someone and are occasionally interested in them as an opinion-potential that offers a out. Projects can also have bodies. The promise gives uncertain promise of a later transformation of the very mirage-like capital into other values, even more solid ones.

The social element as a bearing medium consists, in the worse usual case, of a distraught network of individual nerves in which, apparently, at least one is always stretched to breaking point. This is called group dynamics. On the one hand, this makes the matter relatively rhythmical, perhaps also strenuous, but the internal tension maintains itself, through this alternating dance of resentments, on a continually high level which an individual, at least in the long run, can achieve only with greater difficulty. A further peculiarity of communication beyond several participants is the circumstance that one and the same statement can never ever be passed on and understood identically over several participating relay stations. This offers an automatic space for misunderstandings which are not always constructive.

Each person therefore carries around two or three fragments or keys which, in any case, are always pinching in funny ways and, taken by themselves, are only good for tearing pockets, or do not fit anywhere. Together with other supposedly useless adaptors or empty door locks, under certain circumstances they suddenly turn into a fitting shoe or an open door. It is then rare and beautiful, like a successful soccer play over three to twelve direct contacts with the ball, which finally lands in the goal, hissing and rustling in the net, replete with ballet-like gracefulness. In the case of a congenial group experience (from here on post-production), the ball also becomes bigger and bigger from contact to contact, until it finally does not fit at all in the goal which, however, doesn't matter at all because, in the meantime, the original goal has been transformed into another one, preferably better than the first. In the midst of situation itself, those involved don't notice it, but afterwards they certainly do. The various relay stations in the play, i.e., the persons involved, also gain a lasting profit in personal growth. Everybody only wanted to invent the wheel, but suddenly a whole BMW was built. Or something better. Then, in most cases, one person gets into it and drives off. Roughly to the next dream or the next tree. These are the usual patterns that take place with such beautiful regularity that we would like to believe in morphogenesis in order not to get bored with this kind of social loop. Each person should have his or her own alpha-animal somewhat better under control, or at least sometimes hire it out, which does not mean that power is not at stake, no matter what the angle of incidence or deflection.

Gunter Reski is an artist and co-founder of *STARSHIP* magazine. He was a contributing editor to the magazine from 1998 to 2001.

This essay *Ego sums* has been published in the exhibition catalogue *Circles–Individuelle Sozialisation und Netzwerkarbeit in der zeitgenössischen Kunst* at ZKM, Karlsruhe curated by Christoph Keller in 2000/2001.

Egosummen

Nichts geht über gelungenes Teamwork. Man muss sich nicht immer nur mit sich selber streiten. Das ist absolut nicht zu unterschätzen. Wenn zwei im gleichen Raum dieselbe Idee haben und gut finden, wird sie dadurch meistens besser.

Wenn hier über mögliche Wechselwirkungen von Einzelkünstlerdasein und changierenden Gruppenidentitäten in einer Person die Rede sein soll, ist schwer zu sagen, ob nur das eine für das andere hilfreich oder sogar Bedingung ist, wenn man beides mehrere Jahre parallel praktiziert hat. Vielseitige Identitäten sind nicht nur manchmal beim Versicherungsbetrug hilfreich. Hin und wieder allerdings ist es nicht schlecht, morgens beim Aufstehen zu klären, ob man diesen Tag in Einzel- oder Gruppenbindung beenden wird. Eine Verhältnismässigkeit von Sich-Verzetteln und sich Gegenseitigem-Anregen lässt sich hier kaum nach Effizienzfaktor auswerten. Wie die meisten staatlich sozialisierten Künstlerwerdepläne habe ich mich auch zu lange in einer dieser Kunsthochschulen aufgehalten, aber selbst dort kann die eher indirekte Form der Kooperation, über ein, zwei Semester hinweg in ein- und demselben (Klassen)Raum nebeneinander zu arbeiten, auch nach langer Zeit noch mimetische Vorgänge hervorpurzeln lassen. Man tut dies oder jenes für einen selbst Überraschende, und hoppla, zehn Minuten oder Tage später merkt man, ah, jetzt hab ich den Farbplempertrick oder die Argumentationsschleife von Michael oder Bärbel in den eigenen Gestaltungsapparat einbauen können. Falls ich im lerntechnischen Zusammenhang an etwas glauben müsste, dann an Mimetik. Generell ist es weiter hilfreich, angenommen man neigt zum Rumprobieren, was man sollte, die jeweils unterschiedlichen Arbeitszusammenhänge auch als jeweils unterschiedliche Probebühnen zu nutzen. Was vielleicht im Spätwerk zu sehr querschiesst, passt gut als Projektbeitrag in entsprechenden Vorhaben. Auf eine bestimmte Art zu zeichnen, wäre ich nicht gekommen, hätte ich nicht mal mit einigen Freunden und Kollegen eine Zeitschrift namens „Dank" gemacht. Weiter sind die Vielzahl unmittelbaren Reaktionen, die im Teamwork anfallen als Resonanzboden hilfreich. Auch wenn man nach einiger Zusammenarbeit die jeweiligen Geschmacksraster bedingt einschätzen kann, tauchen hier immer überraschende Urteilsfindungen auf, die eben eigene überfixierte Meinungstechniken und Kriteriensysteme sinnvoll durcheinander bringen können.

Wenn man sich langfristig mehrerer Rollen, Verhalten oder auch Identitäten (Kritik, Kunst, Ausstellungmachen) im Kulturbetrieb bedient, kann es durchaus sinnvoll sein, eine Art Proportionsgefühl im Blick zu haben beim Rollen-Hopping: wird das eine zu präsent in dem einen Wirkungskreis, muss man dementsprechend im anderen Metier zulegen. Oder man ist erst mal in einer bestimmten öffentlichen Wahrnehmung doch wieder mit der nur einen Tätigkeit identifiziert. Hat sich die eine Funktionszuschreibung erst mal allseits festgesetzt, braucht es einiges Steine rücken, bis man z.B. die Zuschreibung vom kruden Schreiberling, der noch zeichnet oder halt umgekehrt, wieder zu aufzulockern. Insofern ist eine recht sensible Platzierungstechnik gefordert, die ähnlich Feinsinn fordert, wie etwa beim richtigen Färbchen an der richtigen Stelle im richtigen Bild, nur anders codiert. So ist mitunter bei Neubekanntschaften die Situation gegeben, dass man vielleicht eher für das Gesprächsgegenüber nur durch das *eine* Tun Neugierde oder Bekanntheit geweckt hat, was sich je nach Belieben aufklären lässt. Natürlich ist auch die Frage, ob man es sich eventuell nicht unnötig schwer macht: es ist ohnehin schon beschwerlich genug, die Welt der Multiplikatoren allein für das eine Projekt oder Getane über zehn Sekunden hinaus zu interessieren.

Erzählt mir jemand, er mache Kunst, kuratiere Ausstellungen und schreibe Kunstkritiken, nehme ich ihn danach nicht unbedingt ernster. An Konzentrationsschwäche muss man nicht immer glauben, aber an Vielbegabungen auch nicht.

Ob man für Doppeltätigkeiten geeignet ist, lässt sich einfach feststellen. Man muss gut mit den beiden Händen parallel jeweils einen unterschiedlichen Takt auf der Tischplatte trommeln und halten können. Oft ist mitunter nicht schlecht, wenn die eine Hand nicht weiss, was die andere tut. Ein Grund für die Distanziertheit gegenüber Positionen, die parallel diverse funktionelle Rollen innerhalb des Kulturbetriebs bespielen, mag sein, dass Tätigkeiten nicht nur zwecks Übersichtlichkeit mit gesellschaftlichen Funktionen und weiter mit Identitäten gleichgesetzt werden. Jemand, der alle drei Tage mit einem neuen Gesicht, aber demselben Namen auftaucht, erkennt man schlecht wieder. Man hat schon oft Probleme, sich zu jedem Gesicht den richtigen Namen zu merken. Wenn man dann weiter da auch noch drei Funktionen zu einem Augenpaar zugeordnet und bewertet werden muss, kommt fast leichter Unmut auf: der oder die beansprucht aber viel Aufmerksamkeit. Man hat immer nur ein Lieblingslied gerade, und auch wenn man zwei hat, kann man nur eines hören. Vom merkantilen Standpunkt aus ist die Sache erheblich einfacher: Die gerade geschlachtete Kuh, die selbst noch die Lebensmittelproben anfertigt und den Preis treibt, erntet Misstrauen.

Trotzdem ist selbstverständlich nicht einzusehen, warum ein striktes Kompetenzgefüge eben nicht gerade auch durch hybrides Rollentwisting belebende Momente erfahren sollte. Im Textfall kann das so aussehen: Schreib einen Text, der auch als Review funktioniert, aber keinerlei formalen Bedingungen dieses Textformats erfüllt, und weiter lasse dabei ruhig Praxiskompetenz sprechen, aber ohne einen dieser lyrisch-verquasten Künstlertexte zu fabrizieren. Heraus kommt wahrscheinlich eine fragil verbalisierte Binnenform zwischen Topf und Deckel.

So wie sich Textgenres um- oder entdefiniert nutzen lassen, sind ähnliche Ambitionen eben auch in den allgemeinen Betriebsstrukturen durch Kompetenzwechsel denkbar. Vorausgesetzt man ist in der Lage, in den jeweils unterschiedlichen Funktionen anhaltende Akzente zu setzen. Natürlich eben nur denkbar, was nicht heisst, dass man nicht mikrokosmosmässig sich in seinem Kiez entsprechend andere Strukturen realisieren liesse. Wenn man will, kann man derlei Vorgehen mikropolitisch nennen. Es ist naheliegend, dass sich ein Betriebssystem, wenn es sich wie das der Kunst weitgehend durch Kontingenz und Undefiniertes speist, zumindest durch eine strikte und starre Aufgabenverteilung in der sozialen Rahmenform seiner BetreiberInnen den Anschein von etwas Definiertem erwecken möchte. Das muss aber nicht am Umstand der Änderungswürdigkeit rütteln. Wenn man McKinsey auf das Wirtschaftssystem ‚Kunst'

insgesamt als ‚eine' Betriebseinheit ansetzen würde, käme es mutmasslich zu der merkantilen Empfehlung, sich besser nicht auf so eine übersichtliche Zahl an Geldgebern festzulegen. Je empfindlicher ein System auch auf nur geringfügige Veränderungstendenzen reagiert, umso grösser ist wahrscheinlich der Reformstau.

Eigentlich ist es eher müssig, nach ideologischen Spannweiten zwischen diesen einzelnen und gruppierten Produktionswegen zu suchen. Diese schwingen freilich nach wie vor diffus mit umher, wenn auch erheblich entideologisierter als vor einigen Jahren. Das Meinungsspektrum in redundant polarisierter Form klingt etwa so: Der gehobene Einzelkünstler ist eine antiquiertes Rolemodel des vorletzten Jahrhunderts oder die verdiente Kollektivkraft braucht zu sehr die produktive Herde als Existenz- und Arbeitsbedingung. Wenn Du schon kein Stein sein kannst, dann sei halt Fuge. Etwas aktualisiert klingen diese Eckmeinungen so: der 19. Jahrhundert Geniekult ist modernisiert worden in Richtung Popstarsystem und die ideologische Kollektivkraft des linken (dtsch.) Michels hat seine neoliberale Entsprechung in der Dotcom-Kraft gefunden, die sich von flach angemalten Hierarchien getäuscht und überidentifiziert jetzt ihre Freisetzung reflektieren darf.

Es gibt einen etwas eigenartigen Umstand namens symbolisches Kapital. Das ist weniger eine Ersatzwährung als ein diffuses Wertungssystem, das sich nominell nach aussen richtet, aber intern verhandelt wird, wobei intern natürlich relativ ist. Symbolisches Kapital erhält eine bestimmte kulturelle Leistung, die annähernd breitgestreut Achtung erzielt hat. Breitgestreut heisst, möglichst auch Konsens erzeugen bei sonst eher gegenüberliegenden Meinungsträgern. Genau, es klingt nach Ehrenamt. Das symbolische Kapital wird gemäss dem Verursacherprinzip dem/der/denjenigen mit einem vagen Versprechen gewissermassen virtuell an den Leib geheftet, d.h. die Leute erkennen einen und interessieren sich hin und wieder für diese als aussenliegend apostrophiertes Meinungspotential. Projekte können auch Leiber haben. Das Versprechen verheisst unsicher eine spätere Umwandlung des sehr schimärenhaften Kapitals in andere, auch festere Wertigkeiten.

Das Soziale als Trägermedium besteht im schlechteren Regelfall aus einem strapazierten Netz individueller Nervenstränge. Bei dem anscheinend immer mindestens eines gerade bis zum Zerreissen gespannt ist. Das heisst Gruppendynamik. Das macht die Sache einerseits relativ rhythmisch, gegebenenfalls auch anstrengend, an sich hält es aber durch diesen abwechselnden Reigen an Ressentiments

die interne Spannung kontinuierlich auf hohem Niveau, das einzeln selbst auf Dauer jedenfalls schwerer herzustellen ist. Eine weitere Eigenart bei Kommunikation über mehrere GesprächsteilnehmerInnen hinweg ist der Umstand, dass sich ein- und derselbe Satz nie und nimmer identisch über mehrere Ansprechenstationen hinweg weitergeben und ident verstehen lässt. Das bietet einen automatisierten Raum für Missverständnisse, die nicht immer produktiv sind.

Jeder trägt so zwei, drei Scherben oder Schlüssel mit sich herum, die eh immer komisch zwicken und für sich genommen höchstens taugen, Hosentaschen zu verletzten oder nirgends passen. Zusammen mit entsprechend anderen vermeintlich unnützen Passstücken oder leeren Türschlössern wird unter Umständen plötzlich ein Schuh oder offene Tür daraus. Es ist dann selten und schön und wie bei einem gelungenen Spielzug (im Fussball) über drei bis zwölf direkten Ballkontakten, die final gelungen im Tor landen und es im Netz voll balletöser Grazie zischt und rauscht. Im Fall eines kongenialen Gruppenerlebnisses—ab hier dann Postproduktion—wird der Ball zudem von Kontakt zu Kontakt immer grösser bis er schliesslich absolut nicht mehr ins Tor passt, was aber überhaupt nichts macht, weil inzwischen aus dem ursprünglichen Planziel ein anderes, möglichst besseres geworden ist. Was die Beteiligten in dem Moment direkt nicht merken, aber hinterher mit Sicherheit feststellen. Die verschiedenen Anspielstationen tragen auch als beteiligte Personen bleibenden Wachstumsgewinn davon. Man wollte eigentlich nur das Rad erfinden, aber plötzlich war schon ein ganzer BMW fertig. Oder was Besseres. Dann setzt sich meistens einer alleine rein und fährt weg. So circa bis zum nächsten Traum oder Baum. Das sind so die üblichen Schemata, die in solch schöner Regelmässigkeit passieren, dass man gern an Morphogenese glauben möchte, nur um sich nicht so langweilen müssen bei dieser Art von Sozialloops. Jeder sollte sein eigenes Alphatierchen etwas besser im Griff haben oder mal verleihen, was nicht heisst, dass es nicht um Macht ginge, in welchem Ein- und Ausfallswinkel auch immer.

Gunter Reski ist Künstler und Gründungsmitglied des *STARSHIP* Magazin, für das er von 1998 bis 2001 als Editor tätig war.

Das Essay *Egosummen* wurde erstmals in dem Ausstellungskatalog *Circles – Individuelle Sozialisation und Netzwerkarbeit in der zeitgenössischen Kunst* am ZKM, Karlsruhe, kuratiert von Christoph Keller in 2000/2001, veröffentlicht.

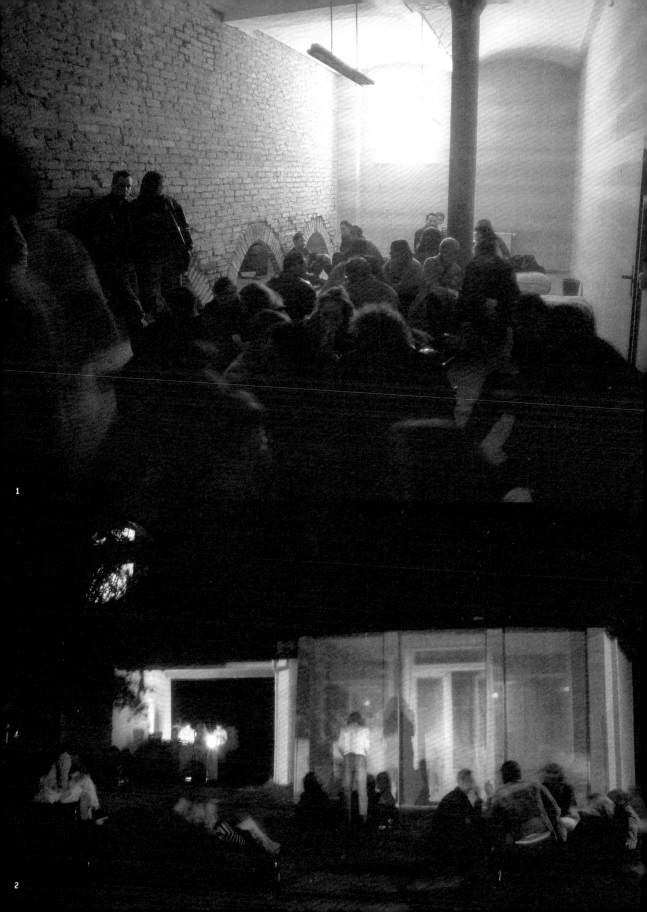

1

2

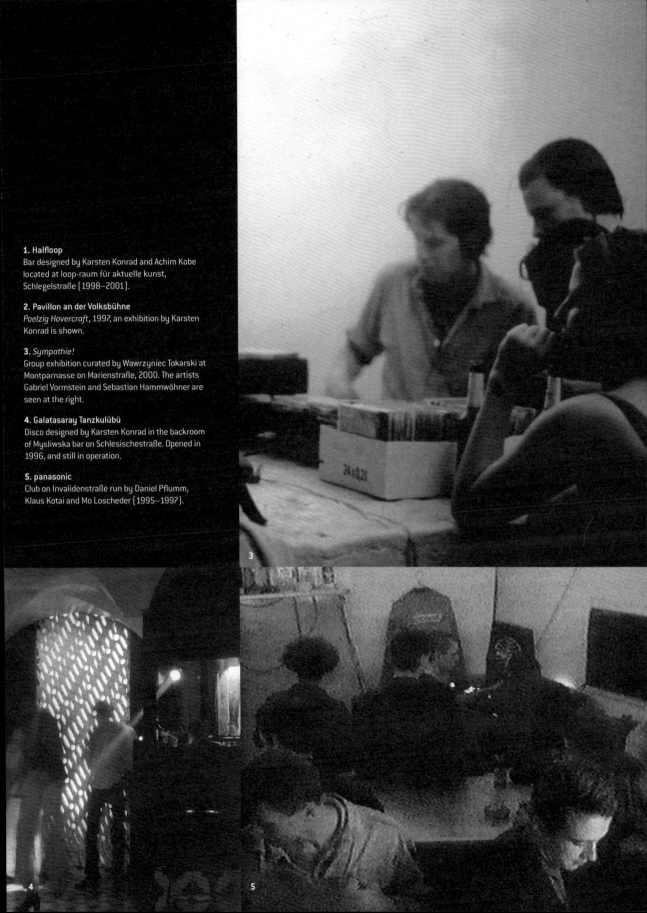

1. Halfloop
Bar designed by Karsten Konrad and Achim Kobe located at loop-raum für aktuelle kunst, Schlegelstraße (1998–2001).

2. Pavillon an der Volksbühne
Poelzig Hovercraft, 1997, an exhibition by Karsten Konrad is shown.

3. *Sympathie!*
Group exhibition curated by Wawrzyniec Tokarski at Montparnasse on Marienstraße, 2000. The artists Gabriel Vormstein and Sebastian Hammwöhner are seen at the right.

4. Galatasaray Tanzkulübü
Disco designed by Karsten Konrad in the backroom of Mysliwska bar on Schlesischestraße. Opened in 1996, and still in operation.

5. panasonic
Club on Invalidenstraße run by Daniel Pflumm, Klaus Kotai and Mo Loscheder (1995–1997).

3

4

5

Children's Communism 1

Ariane Müller

Did it require the Sarah Lucas exhibition to remind us what it looked like on the street, to be precise, on Auguststraße in Berlin-Mitte, about five years ago? Yes, that's how it was, unheated, large rooms, beer counter in the laundry of an unimaginable factory, unsafe paths through unlit backyards. That's how fast you can stage an historicist exhibition. And for the viewers, it's still touch and go: Is that still Berlin, or is that Berlin? Even the travel guide can't keep up.

Things moved fast in Auguststraße, and thank goodness, the town planners will say, who are still counting shoppers in Friedrichstraße. It used to be said that a city counted in its own time spans. Scarcely a developer would really be able to experience the surplus value created by his work. Just think of the Docklands in London.

Jutta Weitz thinks that she would never have expected that the change would come so quickly, when they were sitting together back then: Klaus Biesenbach, Friedrich Look and herself. Jutta Weitz is the woman about whom a critic of the exhibition, *Children of Berlin* (to be seen in New York at the time), recently wrote that her role has never been sufficiently appraised. Can that be done? Jutta Weitz is employed by the Housing Department Berlin-Mitte and is responsible there for allocating commercial spaces. And what she did in the years when the main actors in today's Berlin scene were in New York, Dresden, Charlottenburg, or somewhere else, dropping everything in order to move to Berlin, was to listen, as she says, and to see whether the space people were dreaming of was possible. From Kunstwerke to the WMF, via Hackbarth's and Schröderstraße. It's true that the situation as it is today, a quarter of the population with a homogeneity possible only in a highly capitalized context, arose here on the basis of state sovereignty. Sovereignty right into the personal, her sovereignty, and she, now sitting, and still sitting, at the Housing Department Berlin-Mitte, says: she did not expect, and by no means intended, the way things turned out. Thus a sovereign act of self-surrender, just like much else here in the East, and at the same time she says, that was also my life, and that she liked it. Now, where everything looks so logical (the term gentrification is offered willingly as an explanation of the process), the main actors are looking at each other mistrustfully: we did not have everything in our hands—the last resource, landed property—and who implemented it, and how?

But to say it once more, this is not a story for the business magazine *Econy*, that is, a little historical tale of bureaucracy, and if you look for its roots, then they lie there where someone at one time was able to present themselves in a particularly good light by offering an alternative social plan. Prices per square meter were not negotiated, but rather the promise of offering another way of dealing with the city. An open, experimental situation, a structure corresponding to that new East German image of democracy. That is what Jutta Weitz wanted, as well as to place already established alternative structures before the new ideas about utilization. Under these conditions, the people read as success stories in magazines got their rooms in Berlin-Mitte. The story of what they wanted in the East at that time with their democracy forums is unclear, and I don't know who's interested in it. The landlords in Berlin-Mitte should be able to tell you because they were the ones who knew the right language.

These are all stories from yesterday, and if you look at them from the other end, everything seems so logical, and the term "gentrification" explains everything to us.

Ariane Müller is an artist and co-founder of *STARSHIP* magazine.

This essay *Children's Communism 1* is a reprint from *STARSHIP*, No. 4 (2001).

Kinderkommunismus 1

Hat es Sarah Lucas Ausstellung gebraucht, um daran zu erinnern, wie es in der Straße, Auguststraße in Berlin-Mitte um genau zu sein, vor ca. 5 Jahren ausgesehen hat? Ja, so war das, ungeheizte, grosszügige Räume, Bierausschank in den ehemaligen Waschräumen einer nicht vorstellbaren Fabrik, unsichere Wege durch unbeleuchtete Hinterhöfe. So schnell kann man eine historisierende Ausstellung inszenieren. Und für die BetrachterInnen steht es immer noch an der Kippe: ist das noch Berlin, oder ist das Berlin? So schnell kommt ja der Reiseführer auch nicht mit.

Es ist schnell gegangen, in der Auguststraße und Gott Sei Dank, werden die Stadtplaner sagen, die auf der Friedrichstraße noch die KäuferInnen zählen. Früher hiess es, eine Stadt würde in anderen Zeiträumen zählen. Kaum ein Developer würde den Mehrwert seiner Arbeit wirklich erleben. Man denke an die Docklands in London.

Jutta Weitz meint, dass sie nie gedacht hätte, dass der Umsatz so schnell kommen würde; Als sie damals zusammensassen, Klaus Biesenbach, Friedrich Look und sie. Jutta Weitz ist die Frau, von der kürzlich ein Kommentar zur Ausstellung *Children of Berlin* (eben in New York zu sehen) schrieb, dass ihre Rolle nie genug gewürdigt worden ist. Kann man das? Jutta Weitz ist Angestellte im Wohnungsamt Mitte und dort zuständig für die Vergabe der Gewerberäume. Und was sie gemacht hat, in den Jahren, als die Protagonisten der heutigen Berliner Szene in New York, Dresden, Charlottenburg oder wo sie sonst gerade sassen, eben ihre Kelle fallengelassen hatten, um nach Berlin zu ziehen, war, zuzuhören, sagt sie, und zu schauen, ob das möglich sei, was man sich da an Raum erträumte. Von Kunstwerke bis WMF, über Hackbarth's und Schröderstraße. Es stimmt, dass die Situation, wie sie sich heute darbietet, ein Viertel von einer Homogenität, wie sie sich nur in hochkapitalisierten Zusammenhängen ergibt, hier aufgrund von staatlicher Souveränität entstanden sind. Souveränität, bis hin ins persönliche, ihre Souveränität und

sie nun, immer noch im Wohnungsbauamt Mitte sitzt und sagt: so, wie es jetzt gekommen ist, das hätte sie sich auch nicht gedacht und schon gar nicht gewollt. Also souveräne Selbstaufgabe, wie ja im übrigen viel hier im Osten und gleichzeitig sagt sie, das war doch eben auch mein Leben und sie hat es gemocht. Jetzt, wo alles so logisch aussieht—der Begriff Gentrifizierung erklärt uns gerne den Ablauf—sehen sich die ProtagonistInnen mit misstrauischen Augen an: hatten wir es nicht alle in der Hand—es, die letzte Ressource, Grund und Boden,—und wer hat es, wie, umgesetzt?

Aber um es nochmals zu sagen, das ist keine *Econy* Geschichte, das ist eine kleine feine Historie der Bürokratie und sucht man nach ihren Wurzeln, dann liegen sie dort, wo jemand mal besonders gut darstellen konnte, dass er einen anderen Gesellschaftsentwurf zu bieten hätte. Nicht Quadratmeterpreise wurden verhandelt, sondern das Versprechen einen anderen Umgang mit der Stadt zu bieten. Eine offene, experimentelle Situation, eine Struktur, die jenem neuen ostdeutschen Demokratiebild entsprach. Das wollte Jutta Weitz und den neuen Nutzungsvorstellungen bereits etablierte andere Strukturen vor die Nase setzen und unter diesen Bedingungen haben die Leute, deren Geschichten sich in Magazinen so erfolgreich lesen, ihre Räume in Berlin-Mitte bekommen. Es ist eine unklare Geschichte, was die damals wollten im Osten mit ihren Demokratieforen und ich wüsste nicht, wer sich dafür interessiert. Die Landlords von Mitte müssten es sagen können, weil sie die Sprache bedienen konnten.

Das alles sind Geschichten von früher und sieht man darauf vom anderen Ende sieht alles so logisch aus und der Begriff Gentrifizierung erklärt uns alles.

Ariane Müller ist Künstlerin und Mitherausgeberin des *STARSHIP* Magazine.

Dieses Essay *Kinderkommunismus 1* ist ein Nachdruck aus *STARSHIP*, No. 4 (2001).

Motorradsportgruppe der Berliner Polizei

Die Gruppe der Berliner Polizei bildet den äußeren Kreis der
Inszenierung am Moritzplatz.

Sie fahren ihre grafischen Formationen
(z.B. mit dem Namen Waage, Mühle und Blume)
in einem selbstbestimmten Abstand um den Moritzplatz.
Alle Auf- und Anbauten für die
pensionierten BMW - Polizeimotorrädern
sind von der Gruppe selbst entworfen und gebaut worden.
Jede Einzelkonstruktion ist auf eine Figuration zugeschnitten.
Die sehr genaue berechnete Belastbarkeit
des Materials und der Motorräder lassen bis zu
10 Mann auf einem Motorrad zu.

Die grüne Lederuniform mit den seitlich angebrachten weißen
Streifen machen die Bewegungen fantastisch nachvollziehbar.
Die Choreografien erscheinen wie
lebendige Zeichnungen.

Motorcycle Sporting Group

The group of the Berlin Police forms the outer circle
of the staging on Moritzplatz.

They drive their graphic formations
(e.g. formations entitled Waage (level),
Mühle (mill) and Blume (flower))
In a self-determined distance around Moritzplatz.

All structures and extensions for the
retired BMW police motorbikes are designed
and executed by the group itself.

Every single construction is customized
to one specific figure.

The very precisely calculated capacity
of the material and the motorcycles allow
up to 10 men on one motorcycle.

The green leather uniform with the attached
white stripes on the side allow the movements
to be fantastically comprehensible.

The choreographies appear as life-like drawings.

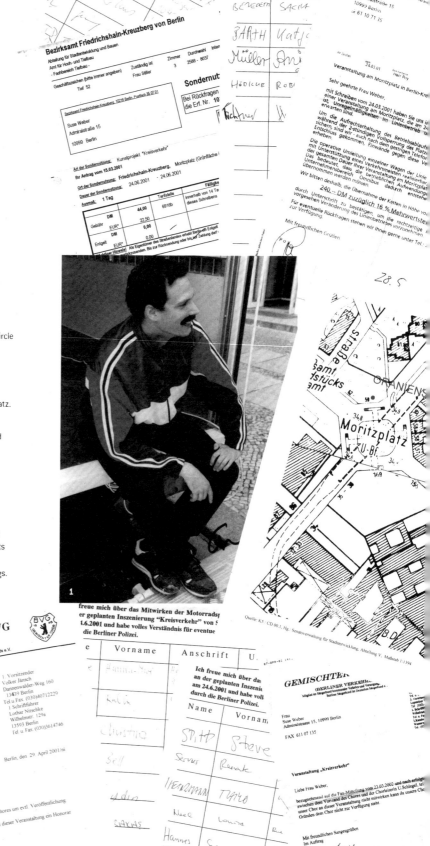

1

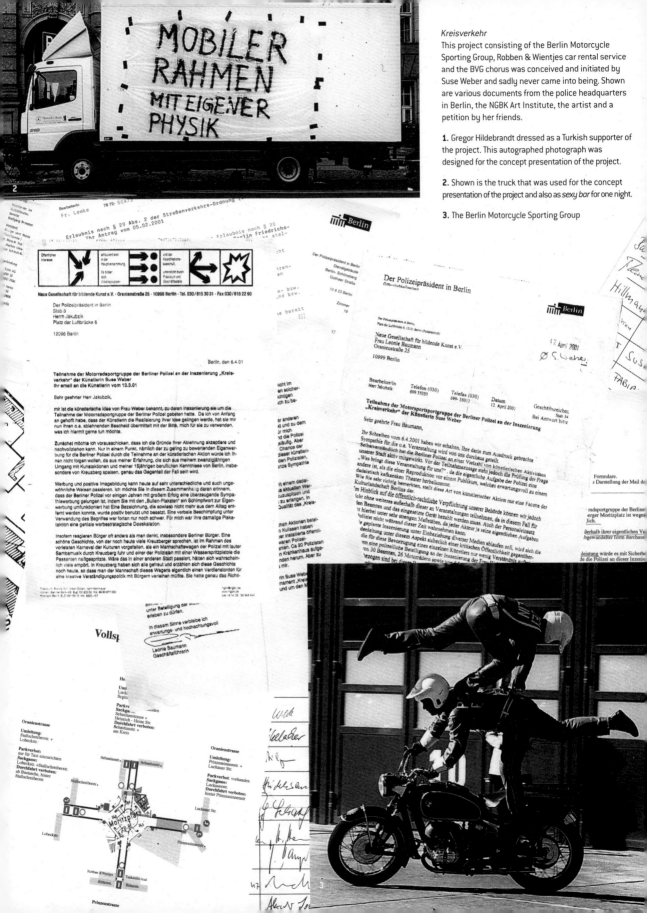

Kreisverkehr

This project consisting of the Berlin Motorcycle Sporting Group, Robben & Wientjes car rental service and the BVG chorus was conceived and initiated by Suse Weber and sadly never came into being. Shown are various documents from the police headquarters in Berlin, the NGBK Art Institute, the artist and a petition by her friends.

1. Gregor Hildebrandt dressed as a Turkish supporter of the project. This autographed photograph was designed for the concept presentation of the project.

2. Shown is the truck that was used for the concept presentation of the project and also as *sexy bar* for one night.

3. The Berlin Motorcycle Sporting Group

Interview with Andreas Koch
by Benita Piechaczek,
September 15, 2002

You are an artist and you run your own gallery. How did that come about and how has the whole thing developed further?

I founded the gallery together with my girlfriend, Sybille Kesslau. At that time I was studying art and in my seventh semester, and Sybille was working part-time. It revolved around the idea of doing something together which in the long run would also amount to securing our existence. However, it was not the top priority to found a gallery, but rather, to bring our abilities together. Therefore, a silkscreen printing workshop was also set up. From the very beginning there was the idea that we could do several things at once.

We then looked around for premises. At first we were interested in Charitéstraße 4. The whole area, however, then fell victim to redevelopment and subsequent gentrification.

At that time I was also working for the newspaper, *Scheinschlag*. I did the layout, sometimes together with Sven Knauth, and at some point he approached me, "You're looking for rooms, aren't you?—I have a little house. . . ." We then had a look at it. It was this two-story shed where he was living with his entire family.

For us the space was ideal. It was immediately clear how we would divide it up: upstairs the office, the ground-floor room for the exhibition space, and at the back the silkscreen printing workshop.

In summer 1996, we rented it and began renovating. In December we had our first exhibition with Reinhard Kühl. At that time he was a fellow student. That could perhaps seem a bit boring, but it wasn't. It was simply superbly classic: six paintings on the wall, each 60 cm square, shots of classic interiors in various historical styles, Biedermeier style, Victorian style, and so on. They were photos of models

that are stored at the Art Institute of Chicago, where a woman had these rooms built seventy years ago on a 1:12 scale. Kühl photographed them and enlarged them to double the miniature room size.

That also had a bit to do with a subject that repeatedly crops up with us. It's a matter of links to architecture, often by means of changes in scale. There are also parallels to my works, and these can also be found occasionally in the exhibitions, falling into the show as if into another world. In any case, we opened the gallery with this in December 1996. A postcard: *Jetzt dabei* was printed on it, along with the gallery stamp.

Well, what's it like when you open up a gallery? Although at that time, as well as today, I still do graphic design in addition to my art, I had a lot of time simply because I am not a studio artist. My artistic work is always project-related. I always had to work a lot for the tours in the HdK (Berlin University of the Arts), mostly in April and May. Then an intensive phase of activity started. In between, however, I had a lot of spare time. If you open up such an exhibition space, there is a strong communicative aspect, simply because you have to talk about art in a different way. But it was also a matter of a hierarchical system of which, as an art student, you only get an inkling and which seems to be very crude, with this brutal art market: at the top is the collector, then comes the gallery owner, the critic stands perhaps to one side, but doesn't earn anything, and the artist is mostly on the lowest rung.

How were you able to finance yourself as a student so that you could still rent extra space?

It has always been the case that I have worked a lot in the area of graphic design, even as a student. For instance, we make the *Motz*, a newspaper for the homeless. In the initial

phase we also made a big atlas for the Stadt und Land Verlag. On the whole, I always had my commissioned jobs, and in the first few years everything was financed by them. Today we have a kind of mixed financing so that every area is co-financed. My work as an artist has also contributed something to this during the past two years. That's how it is at the moment, each area costs something and each area brings in some income.

You two are, so to speak, the founding team?

Exactly. Basically it's still only us two. Only in the graphic design area do I still work together with another friend. It is expanded occasionally, depending on the project.

Do you divide up the areas of work between you, or do you do everything together?

It's relatively well divided up. Sybille mainly does the silkscreen printing, and I tend to do the graphic design. We do the gallery together.

In this way you were able to do the entire public relations work yourselves, printing cards, layout, ...

Exactly. That was a very autonomous principle, even though it is not necessarily cheaper to do everything yourself. We now put much more work into the invitation cards and pay basically just as much as for a mass-produced offset card. But it was also important for us to do it ourselves.

How do you choose your artists, and, in principle, are all the exhibiting artists represented by you?

No, not all, we have a kind of two-class system. It's somewhat difficult. We do that simply to keep us open for exhibitions which we find interesting without including the artists on our list. That would also get to be too much. In our stable—that is, who we present on our art fair lists and represent at fairs—there are thirteen artists in total. We have exhibited around thirty artists. The selection is made basically with the first show. You see from the collaboration whether it fits. Sometimes it is also clear from the beginning that we would like to do more together. Initially, the selection was made more among my fellow students, such as Reinhard Kühl and Nada Sebestyén. From the very beginning we were also under pressure because we had not really planned in advance. At first we looked for gallery premises and then, with the first exhibition, we asked, What are we going to do there?

We basically have a rule that we will not exhibit ourselves as artists. Sometimes, but very rarely, we do break this rule. But it must have a connection with the conception.

The list of artists represented then developed slowly. We showed Kai Schiemenz and Stefan Pente, who were more from the artist squatting scene and had their studios and pads at Strelitzer Straße 61. There was an exhibition with Undine Goldberg who, however, is no longer with us. The painter, Joachim Reck, is still with us. I never wanted this to become a departmental gallery so that you would be put into a kind of slot. Therefore you also have to work quickly against becoming the Gallery of Department 6 of the University of the Arts.

The circle of artists was then expanded beyond your fellow students and friends?

Exactly. Despite that, the program of exhibitions never gets that international flavor. It tends to be the case that you know all the artists and that they also come from Berlin. Almost all of them live in Berlin.

Has it happened that artists came to you as a gallery owner to show you their works?

That happens too. But in fact, nothing has ever come of it; I haven't a clue why. Probably because from the start there is a distance and no rapport. Perhaps the work didn't really knock me out, or it was simply everything together.

Was there ever any collaboration with other institutions? I could well imagine that especially in the difficult initial phase you would need support.

There was a kind of collaboration with other galleries. At the beginning you are still completely up in the air, and run around and display your cards in other galleries so that people will also come to you. There was a certain closeness to neugerriemschneider, for example. They were also here once to see a show by Tilman Wendland, and they thought it was good, and they also liked the space. They then sometimes sent people along to us, which was also very important.

For instance, in the summer of 2000 we did the show, *Berühmte Künstler helfen Koch und Kesslau*. As the title says, it was a matter of inviting famous artists. They were young stars such as Rirkrit Tiravanija, Douglas Gordon, Carsten Höller, Liam Gillick, Philippe Parreno and Pierre Huyghe. They all exhibited here as a group, more or less

organized by Rirkrit. We then moved the silkscreen printing workshop into the exhibition space and made an edition during the opening.

From the institutional side, such as Kunstvereine (art institutes), there hasn't been any collaboration. It also doesn't really fit together. Also things like submitting applications for grants and such we have never done. There have been no applications for supporting a project because we have always financed them ourselves and because it is also too much work, and we don't have any fun doing it.

At the start you mentioned that you manage your time pretty well because as an artist you work in phases and you still have enough time for everything else. Were you ever in a tight situation of having to set priorities or of having to decide on a vocation?

No, that's never really been a problem. If at all, that came only from the outside, the question, that you had to decide on something. I simply don't believe that you have to decide. With regard to time, it's always been that way. We had the gallery from the start, from the beginning of my artistic career. Roughly from the eighth or ninth semester, or after my studies, it began. I did not have a fantastic artistic career, and the gallery, too, is not extremely successful. This means also that the one vocation doesn't swallow you completely. You just have to watch out and put on the brakes. The work as an artist runs more or less parallel. This year has been a bit difficult because there have not been enough exhibition inquiries. I will have to step on the gas a bit more. There are various gas pedals. . . . In the autumn we will really push the gallery, and in October I have an exhibition myself in Capri (a project space in Brunnenstraße). Then, in the winter, I would like to put more emphasis on my own works and make a catalogue for myself. In November we are taking a renovation break for the gallery and the office. So I am never in a time conflict. My artistic work is related to projects and exhibitions, and I always work on them in my mind. You can always do that, just sit down on the grass, or on waking up I think about my works

So founding the gallery was not motivated by trying to create a basis for your existence, since you have always earned enough income.

The basis for my existence is graphic design. But it was also a matter of building up an income-earning basis for both of us, especially for Sybille, because probably I would not have done it. I had studied, had my jobs and an office space where I would have been able to do my graphic design. The further step really came from Sybille. Without her, I probably would never have started a gallery.

Then it also became a necessity because I suddenly had to cover an area that had not been there before. The communication about art and the entire work with exhibitions became very important for me. Operating the gallery gives me the opportunity to draw a lot of people together at one point and show them certain things.

Are you satisfied with your current situation?

Yes. Of course, difficulties come along every now and again because the whole thing has to develop further. If something does not develop further, then you quickly fall into a depression because you have the feeling that nothing's happening anymore. I also no longer want only this routine: sitting in an office that is getting more and more crowded, doing layouts for *Motz* and organizing one exhibition after the other. If there were no perspective beyond that, then things would get awkward. That's why we're now opening another space in Brunnenstraße.

The basic situation for me, however, is completely fine as it is. I can switch back and forth between these vocations and, in this way, always recover from one involvement. There is not this terrible situation of being dependent. I don't have to see the other gallery owners always only as colleagues and try to keep up with their ambition. For me, all that is a little bit restraining. Of course, I also have ambition, but I can always jump into another role and say, "That doesn't interest me one bit." There are also people who criticize me for having this "back door." The quality of the work in all areas must simply be good, even though you have to cut corners with the quantity. In only half the time, you can basically achieve 80 or 90 percent of the quality of a full vocation. The last 10 percent in quality then costs so much time, and that then doesn't matter so much. A lot of people get sucked into a kind of vocational machinery and load themselves to the hilt with appointments and work. My working day does not look like that.

Do you always keep in mind that Koch und Kesslau is not a classic gallery like the others?

Yes, there is a difference there. I also have a feeling of being different, even though we sometimes look the same. That must also be apparent to the artists. They should not be so much in favor of this classic division of labor and say, I have

now left school, and now I'm going into my studio, and my gallery owner will do the rest.

They should be independent and also active in an organizational way. Other galleries even do tax declarations for their artists and take care of the Artist's Social Security. Then the gallery suddenly turns into the artist's family home. With us that's simply not the case.

Are the artists present when the works are installed?

Yes, setting up is really a matter for the artists, and we are there to advise them.

Do you produce catalogues for the artists on your list?

Catalogues are extremely expensive. You really cannot afford them at all. We make leaflets. They are mainly for art fairs, for distribution and for handing out. Then you can do even small print runs and update the biography every now and again.

Let's come back once more to the subject of the artist as curator. Would you say that such projects have increased during the 1990s?

No, I think it has remained on the same level. That was a big thing in the 1980s. There is an entire history of producer-galleries. I recall the Grossgörschen group, who were then professors in my department. These artists had always organized themselves and always made their own exhibitions. Even the Richter-Lueg-Polke exhibition, the first Pop art exhibition in Germany, was self-organized.[1] Every artist probably has the desire at some point to take things into his or her own hands. That has become more of a tendency.

At present, it's receded. Of course, after the fall of the Berlin Wall there were a lot of spaces. But if you really want to do something as an artist, you will find something. Then you will have to make an exhibition in Wedding or in Friedrichshain . . .

In your opinion, has the art of the 1990s changed insofar as some exhibitors are reluctant to accommodate such installations?

I don't think so. The people in the museums today want to have things like that. There was a rupture. Every museum wants to have lounge artists sometimes, with an invited DJ. There is also a movement toward using cheap materials, right up to trash art.

The museums also want to show something like that. I don't think that there are inhibitions. The movements also promote each other. First the galleries show it, then the museums show it, and then it becomes matter of course. Artists have to look for alternative spaces anyway because there are always a lot more artists than exhibition spaces. But it is not the case that the art is too way out for the museums.

Do you exhibit in other galleries?

No, not in galleries. I show my works more in project spaces, self-organized group exhibitions, or in non-commercial institutions. But I am working on changing that situation.

You said that it is the exception that you show in your own works here in the gallery.

Yes. That has happened only twice.

To finish, I have three short questions. The first is, how would you define the social situation of an artist in society?

On the one hand, it is a very free position, set loose from other social systems. On the other, you find yourself under extremely high pressure to finance yourself. Financially, you tend to find yourself on the margins of society. You can conceive this as a great freedom or as continual pressure. Above all, if you have to rely on jobs with an hourly rate of 15–20 marks, that will cost you a lot of time, of course. I personally feel very free and can define my position in society without really being inserted in this system. "Normal" people have this existence of being employed somewhere. I decided on art only after eliminating all other vocational options.

Would you say that the vocation of artist is generally recognized, even outside the art scene?

Not so much as a vocation. The clichés do not disappear from people's minds. No one can imagine that an artist can live off his or her art. You always have to introduce counter-examples and say that a couple of my friends are millionaires, which is true. There are painters of my age who have flown so high that they have earned their first million. But people do not have these cases in mind. They tend to think contemptuously of the Swabian version: Künschtler (artsy-craftsy person).

What do you think the success of an artist depends on? (Of course that is also a question about how you define success.)

There is always a kind of mixture where everything is in balance. First of all, the artist is highly concentrated and has a high degree of ambition. They push their thing to the utmost. They are then discovered by a gallery owner. . . . Yes, that is often the case, and then everything is thrown together come what may, and the artist is launched, and this is then the classic, successful shooting star. But all that also has to fit: the artist must have an enormous ability and output, and must be able to sustain it. Likewise, the gallery must also manage to organize that structurally. I also know a few artists who are so successful that they only fly around from place to place. For me that's not so desirable because you get alienated. You are then asked for the one kind of work for which you stand as an artist. Then it gets very difficult to do anything else.

This description just now is very clichéd. But there is always a good deal of ability and power involved in achieving success. Institutional support is also essential. For me, success is also something else: that I make good works, that I have good exhibitions, and that all three areas work well. That is semi-success and my definition of success. In our gallery, which is very small and tends to have unknown artists, you notice how slowly it builds up, that the names have been heard of, etc.

If one of the artists were with neugerriemschneider, then everything would happen in a flash, within a year: exhibitions here and there and there—the super hype. That's a big difference. What we do is perhaps more stable for the artists because some also lose their heads when they have so much moolah on their account all at once.

Note:

1. Gerhard Richter and Konrad Lueg exhibited their works in a Düsseldorf furniture store on October 11, 1963 among all the furniture on display, under the motto *Living with Pop*, which was conceived as a demonstration for capitalist realism.

Galerie Koch und Kesslau was operated by Andreas Koch and Sybille Kesslau from 1996 to 2004.

Interview mit Andreas Koch
von Benita Piechaczek,
15. September, 2002

Du bist Künstler und betreibst selbst eine Galerie. Wie ist es zu diesem Projekt gekommen, und wie hat sich das Ganze entwickelt?

Die Galerie habe ich zusammen mit meiner Freundin Sybille Kesslau gegründet. Damals habe ich im siebten Semester Kunst studiert, und Sybille hat zu der Zeit gejobbt. Es ging um die Idee, etwas zusammen machen zu können, was in ferner Zukunft auch auf so etwas wie Existenzsicherung hinausläuft. Diese war aber nicht vorrangig. Es war nicht so massgebend jetzt eine Galerie zu gründen, sondern eher unsere Fähigkeiten zusammen zu legen. Deshalb kam zudem die Einrichtung einer Siebdruckwerkstatt zustande. Es gab von Anfang an die Idee, dass man verschiedene Dinge gleichzeitig macht.

Wir suchten dann dafür Räume. Zuerst waren wir an der Charitéstraße 4 interessiert. Das gesamte Areal fiel dann aber der Sanierung und folgenden Gentrifizierung zum Opfer.

Damals arbeitete ich auch für die Zeitung Scheinschlag. Ich machte das Layout, u.a. gemeinsam mit Sven Knauth, und der hat mich irgendwann angesprochen, „du suchst doch Räume..., ich hab' da so'n Häuschen...". Dann haben wir uns das angeschaut. Das war eben diese zweistöckige Remise in der er gewohnt hatte, mit der ganzen Familie.

Für uns war der Raum ideal. Es war eigentlich gleich klar, wie wir das aufteilen werden: oben das Büro, der untere Raum der Ausstellungsraum und im hinteren Teil die Siebdruckwerkstatt.

Im Sommer 1996 hatten wir das angemietet und haben dann erst einmal renoviert und umgebaut. Im Dezember hatten wir dann die erste Ausstellung mit Reinhard Kühl. Er war damals ein Kommilitone. Das sah vielleicht etwas langweilig aus, war es aber nicht. Es war einfach super klassisch: sechs Bilder an der Wand, je ca. 60 x 60 cm gross, Aufnahmen von klassischen Innenräumen aus verschiedenen, historischen Stilen... Biedermeierstil, viktorianischer Stil... Das waren Fotos von Modellen, die im Art Institute of Chicago lagern. Dort hatte eine Frau vor 70 Jahren diese Räume im Massstab 1:12 nachbauen lassen, und Kühl fotografierte sie und vergrösserte die Abbildungen auf das doppelte der Miniaturraumgrösse.

Das hatte dann auch schon ein wenig mit dem Thema zu tun, dass bei uns immer wieder auftaucht. Es geht dabei um Bezüge zur Architektur, oft mittels Massstabsveränderungen. Es gibt da auch Parallelen zu meinen Arbeiten, und es findet sich ab und zu auch in den Ausstellungen wieder, dieses Hineinfallen in die Ausstellung, wie in eine andere Welt. Jedenfalls haben wir damit im Dezember 1996 die Galerie aufgemacht. Postkarte: Jetzt dabei, stand darauf-mit Stempel.

Tja, wie ist das, wenn man eine Galerie aufmacht? Obwohl ich damals wie heute zusätzlich zu meiner Kunst noch Grafikdesign machte, hatte ich viel Zeit, einfach weil ich kein Atelierkünstler bin. Meine künstlerische Arbeit ist immer projektbezogen. Ich hatte dann immer zu den Rundgängen in der HdK viel zu arbeiten, so im April-Mai. Dann fing eine grosse Aktivitätsphase an. Dazwischen hatte ich aber eben viel Zeit. Wenn man so einen Ausstellungsraum macht, ergibt sich ein starken kommunikativer Aspekt-einfach, weil man sich anders über Kunst unterhalten muss. Es ging aber auch um dieses hierarchische System, das man als Kunststudent gerade mal erahnt, und das einem sehr krass vorkommt mit diesem harten Kunstmarkt: an oberster Stelle ist der Sammler, dann kommt der Galerist, der Kritiker steht vielleicht etwas daneben, verdient aber nichts ... aber der Künstler ist ja meistens an der untersten Stufe, eigentlich.

Wie hast du das als Student finanziert, noch einen extra Raum anzumieten?

Es war schon immer so, dass ich viel gearbeitet habe im Bereich Grafikdesign, schon als Student. Zum Beispiel machen wir die Motz (Obdachlosenzeitung). In der Anfangsphase hatten wir auch einen grossen Atlas für den Stadt und Land Verlag gemacht. Insgesamt hatte ich immer meine Aufträge, und darüber hat sich auch die ersten Jahre alles finanziert. Mittlerweile haben wir so eine Art Mischfinanzierung, so dass jeder Bereich mitfinanziert. Auch meine Arbeit als Künstler hat über die letzten zwei Jahre was dazu beigetragen. So ist es im Moment: jeder Bereich kostet etwas und jeder Bereich bringt etwas ein.

Ihr beide seid so zu sagen das Gründungsteam gewesen?

Genau. Das sind im Wesentlichen immer noch nur wir beide, nur im Grafikbereich arbeite ich noch mit einem anderen Freund zusammen. Es erweitert sich je nach Projekt.

Steckt ihr zwischen Euch die Arbeitsbereiche ab, oder macht ihr alles zusammen?

Das ist relativ gut abgesteckt. Sybille macht hauptsächlich den Siebdruck und ich eher das Grafikdesign. Die Galerie machen wir zusammen.

Somit konntet ihr die gesamte Öffentlichkeitsarbeit für euch selbst machen. Karten drucken, Layout ...

Genau. Das war ein sehr autarkes Prinzip, auch wenn es nicht unbedingt billiger ist, alles selbst zu machen. Wir stecken jetzt sehr viel Arbeit in die Einladungskarten und zahlen aber eigentlich genau so viel, wie für eine Offset-Karte in der Massenherstellung. Das war uns aber auch wichtig, das selbst zu machen.

Wie erfolgt die Künstlerauswahl, und werden grundsätzlich alle austellenden Künstler von Euch vertreten?

Nein, nicht alle. Wir haben da so eine Art Zwei-Klassen-System. Das ist etwas schwierig. Wir machen das einfach um uns offen zu halten für Ausstellungen, die wir interessant finden ohne die Künstler in das Programm aufzunehmen. Das würden auch zu viele werden. In unserem Programm, das bedeutet das was wir auf unseren Messelisten aufführen und dort vertreten, sind dreizehn Künstler insgesamt. Ausgestellt haben wir ungefähr dreissig Künstler. Die Auswahl ergibt sich eigentlich mit der ersten Ausstellung. Man sieht dann bei der Zusammenarbeit, ob das passt. Manchmal ist es auch

vorher schon klar, dass wir das gern mehr machen möchten. Anfangs erfolgte die Auswahl mehr unter meinen Studienkollegen, so wie Reinhard Kühl und Nada Sebestyén. Wir waren auch am Anfang sofort unter Druck, weil wir uns das nicht so richtig vorher überlegt hatten—erstmal die Galerie suchen und dann bei der ersten Ausstellung—oh, was machen wir da?.

Wir haben eigentlich so eine Regelung, dass wir uns als Künstler nicht selbst ausstellen. Manchmal, aber sehr selten, brechen wir diese Regel dann doch. Es muss aber in konzeptionellem Zusammenhang stehen.

Das Programm hat sich dann so langsam entwickelt. Wir zeigten dann Kai Schiemenz und Stefan Pente, die waren mehr aus der Künstlerhausbesetzerszene und hatten ihre Ateliers und Wohnungen in der Strelitzer Straße 61. Es gab eine Ausstellung mit Undine Goldberg, die jetzt aber nicht mehr dabei ist. Der Maler Joachim Reck ist noch bei uns. Ich wollte nie, dass dies so eine Fachbereichsgalerie wird und man da gleich in so eine Schublade kommt. Deswegen muss man da auch schnell dagegen arbeiten, dass man da nicht zur „HdK-Fachbereich 6 Galerie" wird.

Der Kreis der Künstler erweiterte sich dann aber über deine Kollegen und Freunde hinaus?

Genau. Trotzdem bekommt das Programm jetzt nie dieses „internationale". Es ist eher so, dass man die Künstler alle kennt, dass die auch aus Berlin kommen ... Fast alle wohnen in Berlin.

Gab es auch schon die Situation, dass Künstler zu dir als Galerist kamen und dir ihre Arbeiten gezeigt haben?

Das gibt's auch. Tatsächlich hat sich daraus aber nie etwas entwickelt, keine Ahnung warum. Wahrscheinlich, weil da von vorne herein so ein Ferne zu dem jeweils Anderen besteht und es da keinen Bezug gibt. Vielleicht hat mich da auch die Arbeit nie so umgehauen, oder es war einfach alles zusammen.

Gab es je Kooperationen mit anderen Institutionen? Ich könnte mir auch vorstellen, dass man gerade in der schwierigen Anfangsphase Unterstützung braucht.

Es gab schon eine Art Zusammenarbeit mit anderen Galerien. Anfangs hängt man ja da noch ganz in der Luft und läuft so herum und legt seine Karten aus in anderen Galerien ...

damit auch mal die Leute hierher kommen. Es gab eine gewisse Nähe zu neugerriemschneider, zum Beispiel. Die waren auch mal hier, zu einer Ausstellung von Tilman Wendland und fanden das auch gut und der Raum war ihnen auch sympathisch. Die haben dann auch immer mal Leute zu uns vorbei geschickt, was ja auch ganz wichtig war.

Im Sommer 2000 haben wir, zum Beispiel, die Ausstellung „Berühmte Künstler helfen Koch und Kesslau" gemacht. Dabei ging es, wie der Titel schon sagt, darum, berühmte Künstler einzuladen. Das waren Jungstars, wie Rirkrit Tiravanija, Douglas Gordon, Carsten Höller, Liam Gillick, Philippe Parreno und Pierre Huyghe. Die haben dann alle hier ausgestellt, als Gruppe, mehr oder weniger von Rirkrit organisiert. Wir haben dann die Siebdruckwerkstatt hier in den Raum geräumt und während der Eröffnung eine Edition hergestellt.

Von institutioneller Seite, wie mit Kunstvereinen, gibt es keine Zusammenarbeit. Geht ja auch nicht so richtig zusammen. Auch diese Dinge, wie Anträge stellen für Förderungen und dergleichen, das haben wir nie gemacht. Es gab keine Projektförderungsanträge, weil wir das immer selbst finanziert haben und weil das auch viel Arbeit ist, die uns nicht so viel Spass macht.

Du hast eingehend erwähnt, dass du mit dem Zeitmanagement ganz gut klarkommst, da du als Künstler „schubweise" arbeitest und dir genug Zeit für alles andere bleibt. Warst du jemals in Bedrängnis, Prioritäten setzen zu müssen oder dich für einen „Beruf" entscheiden zu müssen?

Nein, das hatte ich eigentlich nie. Das kam wenn überhaupt nur von aussen, die Frage, dass man sich entscheiden muss. Ich glaube das einfach nicht, dass man sich entscheiden muss. Zeitlich gesehen war es ja schon immer so. Wir hatten ja die Galerie von Anfang an, seit dem Beginn meiner künstlerischen Laufbahn. So ab dem 8. oder 9. Semester oder nach dem Studium fängt das ja an. Ich hatte jetzt nicht die super-künstlerische-Karriere und auch die Galerie ist jetzt nicht so super erfolgreich. Das bedeutet auch, dass einen nicht der eine Beruf komplett schluckt. Da muss man eben auch aufpassen und sich selbst bremsen. Die Arbeit als Künstler läuft mehr so parallel. Das war in diesem Jahr etwas schwierig, weil es nicht genügend Ausstellungsanfragen gab. Da muss ich dann wieder mehr Gas geben. Ja, da sind so verschiedenen Gaspedale … Im Herbst legen wir noch mal mit der Galerie richtig los und im Oktober habe ich selbst eine Ausstellung im Capri (einem Projektraum in der Brunnenstraße). Dann würde ich gern im Winter wieder mehr Gewicht auf meine eigenen Arbeiten setzen und für mich einen Katalog machen. Im November machen wir in der Galerie und im Büro eine Renovierungspause. Ich befinde mich also nie im Zeitkonflikt. Meine künstlerische Arbeit ist projekt- bzw. ausstellungsbezogen, und ich arbeite daran immer im Kopf parallel. Das kann man ja immer machen, sich auf die Wiese setzen, oder nach dem Aufwachen denke ich über meine Arbeiten nach.

Die Galerie zu gründen entstand also nicht aus der Motivation heraus, eine Existenzgrundlage zu schaffen. Du hattest ja immer ein ganz gutes Auskommen.

Die Existenzgrundlage ist eigentlich die Grafik. Es ging aber auch darum für uns beide eine Existenz aufzubauen. Vor allem für Sybille, denn ich hätte das wahrscheinlich noch gar nicht so gemacht. Ich hatte studiert, hatte meine Jobs und einen Büroplatz, wo ich mein Grafikdesign hätte machen können. Diese Konsequenz kam eigentlich von Sybille. Ohne sie hätte ich wahrscheinlich nie eine Galerie angefangen.

Dann wurde es auch zur Notwendigkeit, weil ich ja plötzlich einen Bereich abdecken musste, der vorher nicht da war. Die Kommunikation über Kunst und die ganze Arbeit mit den Ausstellungen wurde mir sehr wichtig. Der Galeriebetrieb bietet mir die Möglichkeit viele Leute auf einen Punkt zu ziehen und ihnen bestimmte Sachen zu zeigen.

Bist du mit deiner jetzigen Situation zufrieden?

Ja. Es kommen natürlich immer wieder schwierige Punkte, denn es muss sich ja auch weiterentwickeln. Wenn sich etwas nicht weiterentwickelt, dann kommt man eben schnell mal in eine Depression, weil man das Gefühl hat, da passiert nichts mehr. Ich will auch nicht nur diese Routine: in dem Büro sitzen, das immer mehr zuwächst, die Motz layouten und eine Ausstellung nach der anderen machen. Wenn es keine Perspektive darüber hinaus gibt, dann wird's schwierig. Deshalb eröffnen wir jetzt auch noch einen weiteren Raum in der Brunnenstraße.

Die Grundsituation ist für mich jedoch total gut so wie sie ist. Ich kann zwischen den einzelnen Berufen hin und her springen und mich somit auch immer wieder von einer Sache erholen. Es gibt nicht dieses schreckliche Ausgeliefertsein. Ich muss die anderen Galeristen nicht immer nur als Kollegen sehen und versuchen bei deren Ehrgeiz mitzuhalten. Das ist für mich alles ein wenig gedämpft. Natürlich habe ich auch Ehrgeiz, aber ich kann eben in eine andere Rolle hinein

springen und sagen, „das interessiert mich 'n Scheiss!". Es gibt auch Leute, die mir diese „Hintertürchen" vorwerfen. Die Qualität der Arbeit muss einfach in allen Bereichen gut sein, auch wenn man da bei der Quantität Abstriche macht. In nur der Hälfte der Zeit kann man eigentlich 80 oder 90% der Qualität eines Vollberufes erreichen. Die letzten 10% Qualität kosten dann so viel Zeit … und das macht dann ja auch nicht so viel aus. Viele Leute geraten da in so eine Berufsmaschinerie und knallen sich total zu mit Terminen und Arbeit. So muss mein Tag nicht aussehen.

Hast du ständig vor Augen, dass Koch und Kesslau keine klassische Galerie ist, so wie die anderen?

Ja, es gibt da schon einen Unterschied. Ich habe auch das Gefühl anders zu sein, auch wenn wir manchmal gleich aussehen. Das muss auch den Künstlern klar sein. Sie sollten diese klassische Arbeitsteilung nicht so befürworten und sagen, ich bin jetzt aus der Schule raus, ich geh' jetzt in mein Atelier und alles andere macht mein Galerist.

Sie sollten selbständig und auch organisatorisch tätig sein. Andere Galerien machen sogar die Steuererklärungen für ihre Künstler und kümmern sich um die Künstlersozialversicherung. Da wird die Galerie plötzlich das Elternhaus des Künstlers. Das ist bei uns eben nicht so.

Sind die Künstler bei der Installation der Arbeiten dabei?

Ja, Aufbau ist eigentlich Künstlersache, und wir sind eher beratend daneben.

Produziert ihr Kataloge für die Künstler, die ihr im Programm habt?

Kataloge sind sehr, sehr teuer. Das kann man sich natürlich überhaupt nicht leisten. Wir machen Faltblätter. Das ist vor allem für Messen, zum Auslegen und Mitgeben. Da kann man auch kleinere Auflagen machen und auch immer mal wieder die Biografie aktualisieren.

Lass uns noch mal zurückkommen auf das Thema: der Künstler als Kurator. Würdest du sagen, dass derartige Projekte in den neunziger Jahren zugenommen haben?

Nein, ich glaube das ist immer das gleiche Level. Das war ja schon ganz gross in den Achtzigern. Es gibt ja eine ganze Historie der Produzentengalerien. Mir ist da in Erinnerung die Grossgörschen- Gruppe, die dann in meinem Fachbereich Professoren waren. Diese Künstler haben sich schon immer selbst organisiert und auch selber Ausstellungen gemacht. Selbst diese Richter-Lueg-Polke-Ausstellung, die erste „Pop Art Ausstellung" in Deutschland war selbst organisiert.[1] Es gibt wohl bei jedem Künstler irgendwann mal den Wunsch, das auch mal selbst in die Hand zu nehmen. Das ist nicht mehr geworden.

Das wird im Moment eher wieder weniger. Natürlich gab es nach dem Mauerfall in Berlin viele Räume. Aber wenn du als Künstler wirklich was machen willst, findest du auch was. Man muss dann eben eine Ausstellung in Wedding machen oder in Friedrichshain …

Hat sich deiner Meinung nach die Kunst der neunziger Jahre insoweit verändert, dass manche Aussteller Scheu haben derartige Installationen zu beherbergen?

Ich glaube nicht. Die Leute die heute in den Museen sitzen wollen ja so etwas haben. Da gab es einen Umbruch. Jedes Museum will mal „die Lounge"-Künstler mit eingeladenem DJ. Es gibt ja auch eine Bewegung hin zu der Verwendung von Billigmaterialien, bis hin zur Trash-Kunst.

Aber auch so etwas wollen die Museen zeigen. Ich glaube nicht, dass es da Hemmschwellen gibt. Die Bewegungen fördern sich ja auch gegenseitig. Erst zeigen es die Galerien, dann zeigen es die Museen und dann wird es Gang und Gebe. Künstler müssen eh nach alternativen Räumen suchen, denn es gibt immer viel mehr Künstler als Ausstellungsmöglichkeiten. Es ist aber nicht so, dass die Kunst zu abgefahren für die Museen ist.

Stellst du in anderen Galerien aus?

Nein, nicht in Galerien. Ich zeige meine Arbeiten mehr in Projekträumen, selbstorganisierten Gruppenausstellungen oder in nicht kommerziellen Institutionen. Ich strebe aber an, dass sich das ändert.

Du sagtest es ist eher die Ausnahme, dass du dich hier in der Galerie selbst ausstellst.

Ja. Das war nur zwei Mal.

Zum Schluss habe ich noch drei kurze Fragen. Die erste ist: Wie würdest du die soziale Stellung eines Künstlers in der Gesellschaft definieren?

Einerseits ist das eine sehr freie Position, losgekoppelt von anderen gesellschaftlichen Systemen. Andererseits befindet

man sich unter extrem hohem Selbstfinanzierungsdruck. Finanziell befindet man sich eher am Rande der Gesellschaft. Man kann das als grosse Freiheit begreifen oder als ständigen Druck. Vor allem, wenn man auf Jobs angewiesen ist, mit einem Stundenlohn von 15-20 Mark, das kostet natürlich sehr viel Zeit. Ich persönlich fühle mich sehr frei und kann meine Position in der Gesellschaft selbst definieren, ohne in diesem System richtig drin zuhängen. So „normale" Leute haben dieses Angestelltendasein ... Auf Kunst kam ich eigentlich nach Eliminierung aller anderen Berufsmöglichkeiten.

Würdest du sagen, dass der Beruf Künstler allgemein anerkannt ist (auch ausserhalb der Kunstszene)?

Als Beruf eher nicht. Die Klischees gehen auch nicht aus den Köpfen raus. Keiner kann sich überhaupt vorstellen, dass irgendein Künstler davon leben kann. Da muss man dann immer mit Gegenbeispielen kommen und sagen: „also ein paar meiner Freunde sind Millionäre", was ja auch stimmt. Es gibt ja Maler in meinem Alter, die so hochgeschossen werden, die haben ihre erste Million verdient. Solche Fälle sind aber nicht im Bewusstsein der Leute. Da wird eher verächtlich in der schwäbischen Version gedacht: Künschtler.

Was glaubst du, wovon der Erfolg eines Künstlers abhängt? (Allerdings ist da ja auch eine Frage, wie man Erfolg definiert.)

Das ist immer so eine Mischung, wo alles stimmt. Erst einmal ist der Künstler sehr konzentriert und hat eine grosse Portion Ehrgeiz. Die ziehen ihr „Ding" voll durch. Das wird dann von einem Galeristen entdeckt ... Ja, ich glaube so ist es oft ... und dann wird es aber auch auf Gedeih und Verderb zusammengeschmissen und der Künstler hochgeschossen. Das ist dann der klassische, erfolgreiche Shootingstar. Das muss aber auch alles passen: der Künstler braucht eine enorme Leistungskraft, vom Arbeitsausstoss, und das muss er auch halten. Genauso muss auch die Galerie es schaffen, das strukturell zu organisieren. Ich kenne auch einige Künstler, die sind so erfolgreich, die fliegen nur noch umher. Das ist für mich nicht so erstrebenswert, weil es entfremdet. Es wird dann auch nach einer Art von Arbeit gefragt, für die der Künstler steht. Es wird dann sehr schwierig mal etwas anderes zu machen.

Diese Beschreibung war jetzt sehr klischeehaft. Aber es sind immer einige Portionen an Leistungskraft, die zusammen den Erfolg ausmachen. Institutionelle Förderung ist total wichtig. Für mich ist Erfolg auch noch etwas anderes: dass ich gute Arbeiten mache, dass ich gute Ausstellungen

habe und dass alle drei Bereiche gut funktionieren. Das ist Semi-Erfolg und meine Definition von Erfolg. In unserer Galerie, die sehr klein ist und eher unbekannte Künstler hat, merkt man wie langsam sich das aufbaut, dass die Namen mal gehört worden sind usw.

Wäre einer der Künstler bei neugerriemschneider, dann ginge das so puff innerhalb eines Jahres—Ausstellungen da und da und da, der Super-hype. Das ist ein grosser Unterschied. Was wir machen ist vielleicht stabiler für die Künstler, weil da auch einige durchknallen, wenn sie auf einmal so viel Kohle auf dem Konto haben.

Note:

1. Gerhard Richter und Konrad Lueg stellten am 11. Oktober 1963 ihre Arbeiten in einem Düsseldorfer Möbelhaus inmitten der Ausstellungsstücke zur Schau; die Veranstaltung unter dem Motto: „Leben mit Pop" verstand sich als eine Demonstration für den kapitalistischen Realismus

Andreas Koch und Sybille Kesslau betrieben die Galerie Koch und Kesslau von 1996 bis 2004.

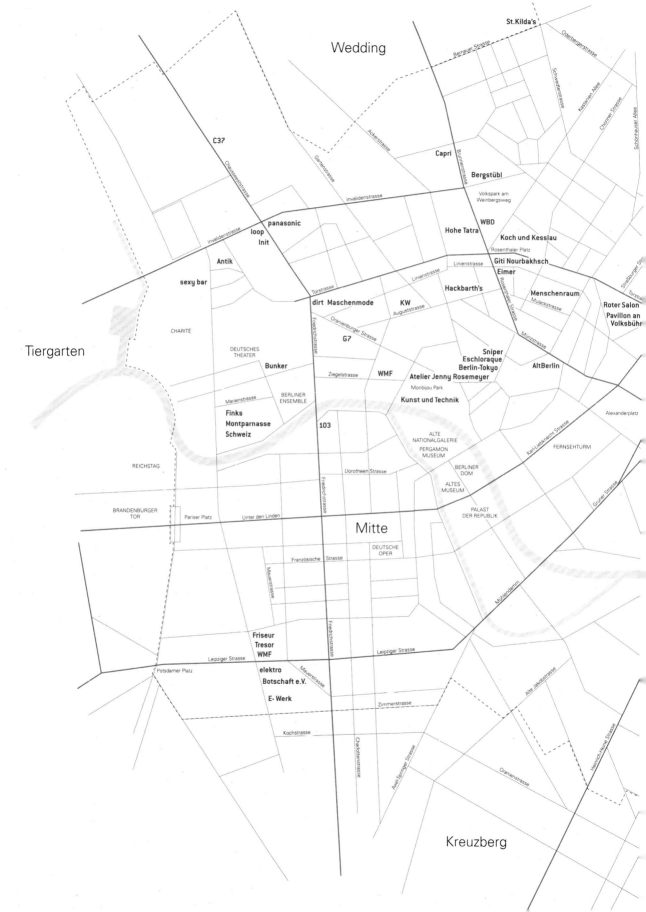

Prenzlauer Berg

Luxus

orter Strasse

Greifswalder Strasse

uer Allee

Otto-Braun-Strasse

Volkspark Friedrichshain

Mollstrasse

Karl Marx Allee

Friedrichshain

Straußberger Platz

Glaskasten >

Maria am Ostbahnhof >

Koepenicker Strasse

Adalbertstrasse

Bethanien

Mysliwska >

3K

nstrasse

Untitled

2002

Mixed media on paper
38.9 x 28.7 cm / 15 1/4 x 11 1/4 in

1969
born in München, Germany

Dirk Bell

I ran Finks from 1999–2001 and also co-founded the Schweiz, but left that project after a while. Schweiz then became Montparnasse, a collaboration with Thilo Heinzmann and Anselm Reyle that I again co-initiated. Finks and Montparnasse were in the same building on Marienstraße 1 – Finks was a bar one flight above the exhibition space.

In 2001/2002 Sergei Jensen and I prepared a weekly evening at Antik.

C37 on Chausseestraße 37 was another bar that I did, together with Jonathan Graham, who formerly managed the Kunst und Technik, C37 existed in 2002/2003.

1 Million $ Knödel Kisses

2001–2002

Mixed media
Dimensions variable

Installation view, documenta 11, Kassel, 2002

1965
born in Gribbohm, Germany

lives and works in Berlin

John Bock

In addition to this installation, John Bock will hold a performance on the opening night.

2 Tonnen Alte Nationalgalerie
1998

Rubble from the façade of the Alte Nationalgalerie, Berlin
Dimensions variable

Installation view, *Kamikaze*, group exhibition, Marstall, Berlin, 1998

1965
born in Venice, Italy

1986–93
Hochschule der Bildenden Künste Berlin

1991–92
California Institute of the Arts, Valencia,
California, USA

has lived and worked in Berlin since 1986

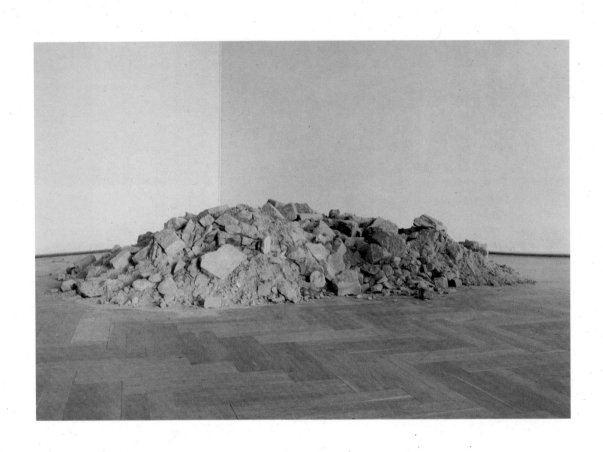

Friedens-Siemens I

2000

Acrylic and oil on canvas
230 x 165 cm / 90 $^1/_2$ x 65 in

André Butzer

1973
born in Stuttgart, Germany

1996–2000
Akademie Isotrop, Hamburg

lived and worked in Berlin from 2000–2006
currently lives and works in Rangsdorf,
Brandenburg

My favorite club in Berlin in 2000 was dirt, next to Maschenmode on Torstraße.

I co-organized and co-curated the show FRIEDE, FREIHEIT, FREUDE at Maschenmode.

Björn Dahlem and I curated Sibirien Forellen Express at Maschenmode, featuring Thilo Heinzmann.

DER WANDEL was a movement, a social grouping, that Erwin Kneihsl founded. I was his flat mate at that time and therefore involved in the resulting magazine, shows and travel of about 25 artist friends to Lodz, Poland in January 2001. Including among others Thomas Helbig, Thilo Heinzmann, Suse Weber, Tine Furler, Marcus Selg, Jenny Rosemeyer, Guido W. Baudach, Anselm Reyle, Marten Frerichs, Eva-Maria Wilde, Erwin Kneihsl and me. It was a lot of drinking combined with a strict regimen of art-education.

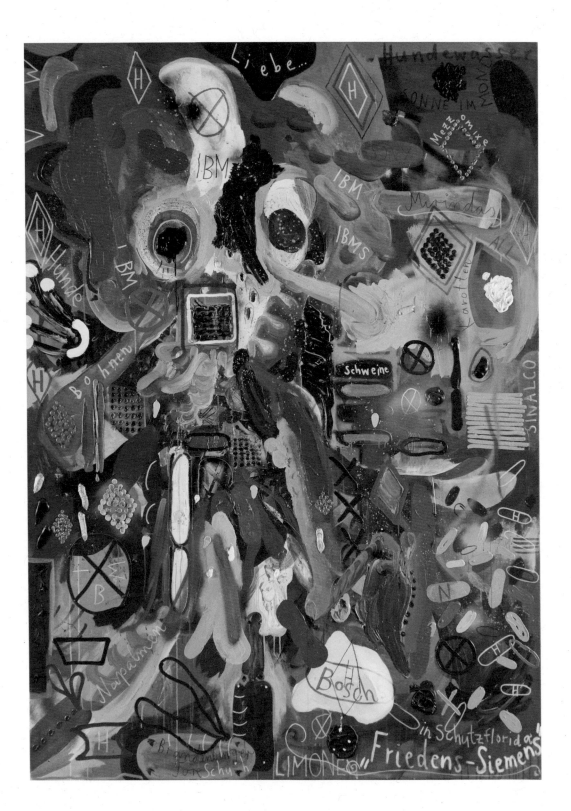

Club Schrödingers Katze

2000 / 2009

Wood, fluorescents, carpet, cat tree, cat litter, book and lamp
Dimensions variable

Installation view, Auckland Art Space, New Zealand, 2000

Björn Dahlem

1974
born in München, Germany

1994–2000
Kunstakademie Düsseldorf

has lived and worked in Berlin since 1999

André Butzer and I curated *Sibirien Forellen Express* at Maschenmode, featuring Thilo Heinzmann.

I showed my work with Maschenmode (Guido W. Baudach) and at Menschenraum (Thomas Zipp).

Played records at dirt and Finks.

Often went for a drink to Bergstübl, and had a beer with basically everybody there, though mostly with André Butzer, Markus Selg, Guido W. Baudach and Thomas Helbig.

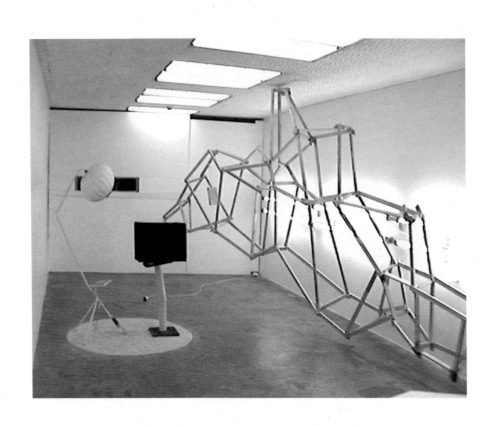

The Skinned Rabbit's Running Nose

2001

Wallpainting

Installation view, *WANDBILDER*, Atelier Jenny Rosemeyer, Oranienburger Straße 3, Berlin, 2001

1968
born in Augsburg, Germany

1986–93
Fachhochschule Augsburg

1993–95
Akademie der Bildenden Künste Nürnberg

1995–96
GHK Gesamthochschule Kassel

1996–2001
Hochschule für Bildende Künste Dresden,
class of Eberhard Bosslet

Novaphorm™ was a collaboration that Lisa Junghanß and I established in 1996. A label with distinctive Corporate identity, resulting in clubs, a chill-out place, lectures, beautystyle, hotel and other products. The first venue was a club on Gipsstraße 16, followed by clubs at Schwarzenberg e.V. (Elektrolux Lounge), Voxxx Chemnitz, a hotel at documenta 10 in Kassel, and so on.

1996
Novaphorm™ disco - Galerie Gipsstraße

1997
Novaphorm™ made in heaven - P.S.1, New York
Novaphorm™ chill out - Galerie VOXXX, Chemnitz
Novaphorm™ electrolux-club - Galerie Schwarzenberg
Novaphorm™ hotel - Kassel, Kassel
Novaphorm™ recycling hotel - Sammlung Hoffmann

1998
Novaphorm™ beautystyle - Galerie Arndt & Partner
Novaphorm™ labeling - WMF, Berlin

2000
Novaphorm™ aroma, Z2000, Akademie der Künste

Untitled (Dürersee)
2000

Watercolor and graphite on newspaper and Chinese paper, pastel on cardboard
250 x 215 cm / 98 $^3/_8$ x 84 $^5/_8$ in

Sebastian Hammwöhner

1974
born in Frechen, Germany

1995–2001
Staatliche Akademie der Bildenden
Künste Karlsruhe

has lived and worked in Berlin since 2001

Dani Jakob

1973
born in Freiburg, Germany

1996–2002
Staatliche Akademie der Bildenden
Künste Karlsruhe

has lived and worked in Berlin since 2001

Gabriel Vormstein

1974
born in Konstanz, Germany

1995–2001
Staatliche Akademie der Bildenden
Künste Karlsruhe

has lived and worked in Berlin since 2001

Exhibitions where the artists presented their collaborative work include:

2000
Sympathie!, Montparnasse
Genre Painting, G7
Face the Black, works from the collection of Thomas Zipp, Maschenmode
Corriger la fortune, Montparnasse

2001
MONTANA SACRA (Circle 5), ZKM, Karlsruhe
Die Vertreibung der Händler aus dem Tempel, 2yk-Galerie, Kunstfabrik
WANDBILDER, Atelier Jenny Rosemeyer, Oranienburger Straße 3

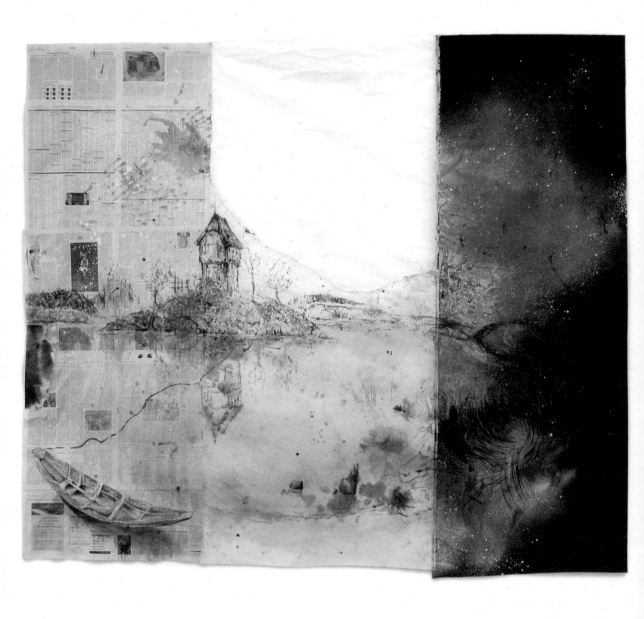

o.T.

1999

Pigment and epoxy on styrofoam in plexiglass case
152 x 202 x 11 cm / 59 $^7/_8$ x 79 $^1/_2$ x 4 $^3/_8$ in

1969
born

1992–1997
Städel, Hochschule für Bildende
Künste, Frankfurt/Main

lives and works in Berlin

1997
Thilo Heinzmann, solo show, Galerie Neu
To show you what's Neu, Galerie Neu

1999
Malerei, Init Kunsthalle

2000
Genre Painting, G7

2001
MONTANA SACRA (Circle 5), ZKM, Karlsruhe
Sibirien Forellen Express, curated by Björn Dahlem and André Butzer, Maschenmode
WANDBILDER, Atelier Jenny Rosemeyer, Oranienburger Straße 3

2002
When a woman loves a man, solo show, Galerie Guido W. Baudach
FRIEDE, FREIHEIT, FREUDE, Galerie Guido W. Baudach
Grosse Kunstausstellung Sommer 2002 im Pazifik, PAZIFIK

Ikone

2000–2001

Oil on canvas
158 x 135 cm / 62 ¼ x 53 ⅛ in

Thomas Helbig

1967
born in Rosenheim, Germany

1989–95
Akademie der Bildenden Künste München
Goldsmiths College, London, UK

has lived and worked in Berlin since 1999

My favorite place was, what a surprise, Maschenmode.

In 2000 I organized the show Deutsch Britische Freundschaft: *DIE GEFAHR IM JAZZ* in my flat on Straßburgerstraße 4.

And another Deutsch Britische Freundschaft (*IM WANDEL DER LIEBE ZU UNS SELBST UND DES GESICHTSINNS IM ALLGEMEINEN*) at Maschenmode in 2001. I showed the work *Ikone* there, which is now going to be in this exhibition.

Deutsch Britische Freundschaft was a project founded by Keith Farquar and myself in 1995 in London. We had rented a huge space in East London where we lived and worked and organized exhibitions and other stuff/projects for a couple of years. Hence basically a kind of off-space in the apartment.

After I moved to Berlin in 1999, Keith and I organized the above shows. We included artists friends such as Enrico David, Lucie McKenzie and Alan Michael from GB and many others. From the Krauts there were artists such as André Butzer, Joseph Kramhöller and Berthold Reiss.

In 2000 Dirk Bell, Anselm Reyle, and Thilo Heinzmann invited me for a solo show in their off space, Montparnasse. The show was entitled *DIE MALEREI DER HEIDEN*.

I had a solo show at Maschenmode in 2001.

Solitude

2001

Oil on canvas
50 x 40 cm / 19 $^3/_4$ x 15 $^3/_4$ in

Uwe Henneken

1974
born in Paderborn, Germany

1997–2002
Staatliche Akademie der Künste Karlsruhe
Hochschule der Bildenden Künste Berlin

has lived and worked in Berlin since 2000

2000
Corriger la fortune, Montparnasse
Sympathie!, curated by Wawa Tokarski, Montparnasse
Face the Black, works from the collection of Thomas Zipp, Maschenmode
Genre Painting, G7

2001
MONTANA SACRA (Circle 5), ZKM, Karlsruhe
WANDBILDER, Atelier Jenny Rosemeyer, Oranienburger Straße 3
Die Vertreibung der Händler aus dem Tempel, 2yk-Galerie, Kunstfabrik

My favorite rooms in Berlin back then were Montparnasse and Finks.

Alice im Wandel (7. Januar 79)

2001

Cassette tape and mixed media on paper
41.2 x 29.6 cm / 16 1/4 x 11 1/4 in

Gregor Hildebrandt

1974
born in Bad Homburg, Germany

1995–1998
Johannes Gutenberg-Universität, Mainz

1999–2000
Hochschule der Bildenden Künste Berlin

I moved to Berlin in 1998 with a VW Kombi that belonged to Uwe Deppisch in order to prolong my studies (for private reasons). Directly thereafter I went to Thomas Scheibitz's opening at loop, when it was still located at Schlegelstraße, and from there to the *Vivienne* concert of Thomas Zipp, Sergej Jensen, and Matthias Vatter in the Init bar on Chaussestraße. Further favorite places were the Kunst und Technik (right at the spree riverside right across from the Bodemuseum), the Dienstagsbar at Schröderstraße, and on Sundays *Finks* (run by Dirk Bell on Marienstraße 1).

2000: moving into the community on Münzstraße 10 with Axel Geis I co-curated several exhibitions, such as *Genre Painting*, for G7, including Wawa Tokarski, Dirk Bell, Thilo Heinzmann, Thomas Helbig, René Lück, Gunter Reski, Jenny Rosemeyer, Gabriel Vormstein, Sebastian Hammwöhner, Suse Weber, Gert und Uwe Tobias, Axel Geis, Michel Majerus, Anselm Reyle, Thomas Zipp, Dirk Skreber, Thomas Scheibitz, Andreas Hofer and Uwe Henneken—summing up to a really big group of artists. There were over one-hundred of us and for the first time, the different scenes of Berlin were shown. Montparnasse was also pretty cool as a show room, dirt was cool for disco and the Pogo Club at KunstWerke on Auguststraße was okay too. Later on Zipp ran his Menschenraum on Mulackstraße.

Back at that time there was an endless number of off-spaces just like WBD, where I had my first solo show in 2002, entitled *Tönende Jugend*.

In 2002 I was also responsible for a larger group show on the topic of music, entitled *Sounds*, presented at G7. The exhibition included contributions by Dieter Kiessling, Stefan Müller, John Armleder, Gabriel Vormstein, Alex Heim, Alicja Kwade, Thomas Beyerle and Dirk Bell. Again over one-hundred artists but the over-all outcome was not that good this time.

Siwelmego
Styczień 79

Getting Rid of Stuff

2001

Video loop
7 minutes
Edition of 20 + 1 AP

1972
born in Stockholm, Sweden

1992–1995
Sheffield Hallam University, Sheffield, UK

has lived and worked in Berlin since 1997

Sofia Hultén

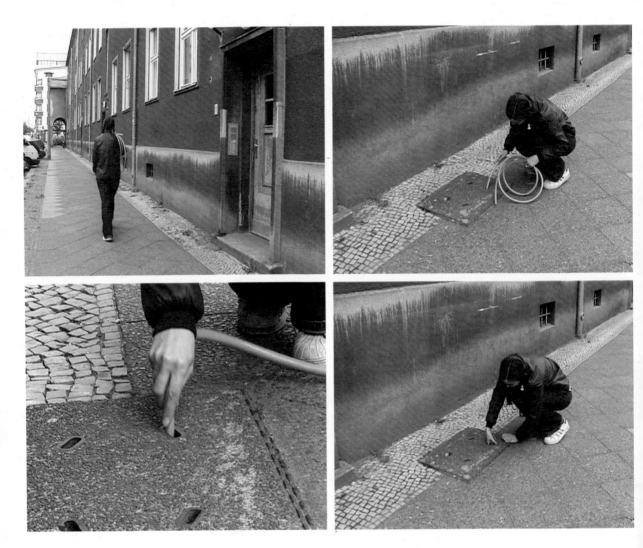

TYCO NOT TYCO

2000 / 2001

Slot car racetrack, MDF
180 x 240 x 50 cm / 70 7/8 x 94 1/2 x 19 3/4 in

Installation view, Koch und Kesslau, Berlin, 2002

Klaus Jörres

1973
born in Düren, Germany

1994–1996
Philosophy, Psychology, Sociology at
Rheinisch-Westfälisch Technische
Hochschule Aachen

1996–1999
Akademie beeldende Kunsten Maastricht,
The Netherlands

1999–2002
Hochschule der Bildenden Künste Berlin,
class of Katharina Sieverding

has lived and worked in Berlin since 1999

Well, it started in 2001, when Andreas Koch made me offers, trying to convince me to show with his gallery. My exhibit at Baudach's Maschenmode in 2000 had been a raving success, like everything at that place. I was extremely busy: theory, production, exhibition.

Furthermore, the whole set of weekly bars, Kunst und Technik on Chausseestraße, dirt, etc.—one did not have a free mind for such kind of blatant decisions. Money was no object—we all had money to burn. Koch continued to boost his offer, and eventually, even for back then, we were talking about a massive amount of cash for a show. By then I had already been banned from dirt four times.

2000
Maschenmode
Banned from dirt four times

2002
Koch und Kesslau

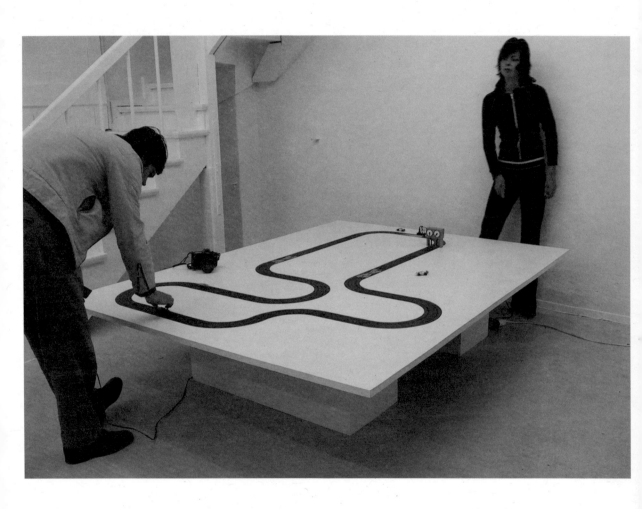

my mommy part II
2000

Video loop
6 minutes
Edition of 3 + 2 AP

Lisa Junghanß

1971
born in Döbeln, Germany

1993–1995
Communication Design at FH Augsburg

1995–2000
Hochschule für Bildende Künste Dresden

has lived and worked in Berlin since 1999

My favorite club was based in a former toilet area at Rosenthaler Platz. Good exhibition spaces were Init- Kunsthalle and G7, where I also showed my work. I especially liked the home-made places in private flats, that several artists ran in Berlin.

It was a habit to invite about 50 artist friends and exhibit all of them in the apartment for just one night. So there was a little show with a great party, packed by masses of artist friends. A great example is the *WANDBILDER* in early 2001 at Jenny Rosemeyer's home on Oranienburger Straße.

Novaphorm™ was a collaboration that Martin Eder and I established in 1996. A label with distinctive Corporate identity, resulting in clubs, a chill-out place, lectures, beautystyle, hotel and other products. The first venue was a club on Gipsstraße 16, followed by clubs at Schwarzenberg e.V. (Elektrolux Lounge), Voxxx Chemnitz, a hotel at documenta 10 in Kassel, and so on.

1996
Novaphorm™ disco - Galerie Gipsstraße

1997
Novaphorm™ made in heaven - P.S.1, New York
Novaphorm™ chill out - Galerie VOXXX, Chemnitz
Novaphorm™ electrolux-club - Galerie Schwarzenberg
Novaphorm™ hotel - Kassel, Kassel
Novaphorm™ recycling hotel - Sammlung Hoffmann

1998
Novaphorm™ beautystyle - Galerie Arndt & Partner
Novaphorm™ labeling - WMF, Berlin

2000
Novaphorm™ aroma, Z2000, Akademie der Künste

Johannes Kahrs

1965
born in Bremen, Germany

lives and works in Berlin

What comes to my mind, when I try to remember the time in Berlin between 1989 and 2000, was the absence of or the distance to a market and galleries, for both myself and other artists and the freedom to do what we liked to do.

I studied at the Berlin Hochschule der Künste, an old fashioned place for worn out, lazy, selfish teachers, who, with a few exceptions, didn't care a bit for what was going on in the world I thought, but therefore we had time, lots of time.

I travelled to Spain and I had seen the documenta in 1992.

When I came back from Spain, I had a vague idea of what I would do, but there was also a very stimulating atmosphere in Berlin.

In 1992 I met people who had formed into loose groups and ran spaces that were something in between bars, clubs and exhibition spaces. There were discussions, lectures, performances, films, parties and lots to drink. Most of these spaces do not exist any longer. Some were torn down and replaced by office buildings. Some, like the KunstWerke, are still around but the house on Invalidenstraße, where Mutzek, and later panasonic, were located, is sealed off—in ruin and still empty.

These two places were called Mutzek and Friseur with the Botschaft collective. Mutzek was more poetic and was based on the energy of Ivonne Harder. It was located in an old Berlin Mietshaus, which was completely squatted by various people from all over. There was an old butchery in the basement with beautiful tiles, and in the back room the floor sunk downwards, I believe to collect the blood of the animals who were slaughtered there before. This room had white tiles and the two rooms were theatre, bar and exhibition space in one.

I somehow got into the group around Ivonne and the strange evenings at Mutzek with Russian musicians and the bicycle pipeline to Bahnhof Friedrichstraße to get new vodka.

I recall the performance of—I forgot his name [Rikrit Tiravanija]—an artist cooking Asian food in the space and serving the food to the audience. Often I woke up the next day on a sofa, I did not have a room in the house and always went home to paint. I never had a more timeless feeling than in these two years of 1992 and 1993 in Berlin. The city seemed to sleep, the buildings were abandoned and run down, more artists came, but the rent was so low and often there was no heating, no water, no electricity and the drinks were cheap. Sometimes helping behind the bar and then later drinking for free.

There were no cafes and we drank the beer on the sidewalk. I remember Tom with his huge motorola mobile, but it was before that time and the internet just started, so we knew where we would meet friends and where to hang out, without making many phone calls.

The Friseur and Botschaft .e.V. was different from Mutzek, but also there was an exchange between the two. The Friseur was similar to Mutzek, a bar, club, exhibition space, film theatre in one, and I never really knew, even if I did, what would be happening each night.

Botschaft was a group of artists and filmmakers, people who were already working with the web, people who started to make clubs, like wmf or panasonic and others. I realized that everything held the possibility to be engaged with; exhibition or lecture, party or catalogue, and it was that, which I didn't find in art school.

Untitled (Schmerz)
1994–1996

Oil on canvas
110 x 165 cm / 43 3/4 x 65 in

What comes to my mind, when I try to remember the time in Berlin between 1989 and 2000, was the absence of or the distance to a market and galleries, for both myself and other artists and the freedom to do what we liked to do.

I studied at the Berlin Hochschule der Künste, an old fashioned place for worn out, lazy, selfish teachers, who, with a few exceptions, didn't care a bit for what was going on in the world I thought, but therefore we had time, lots of time.

I travelled to Spain and I had seen the documenta in 1992.

When I came back from Spain, I had a vague idea of what I would do, but there was also a very stimulating atmosphere in Berlin.

In 1992 I met people who had formed into loose groups and ran spaces that were something in between bars, clubs and exhibition spaces. There were discussions, lectures, performances, films, parties and lots to drink. Most of these spaces do not exist any longer. Some were torn down and replaced by office buildings. Some, like the KunstWerke, are still around but the house on Invalidenstraße, where Mutzek, and later panasonic, were located, is sealed off—in ruin and still empty.

These two places were called Mutzek and Friseur with the Botschaft collective. Mutzek was more poetic and was based on the energy of Ivonne Harder. It was located in an old Berlin Mietshaus, which was completely squatted by various people from all over. There was an old butchery in the basement with beautiful tiles, and in the back room the floor sunk downwards, I believe to collect the blood of the animals who were slaughtered there before. This room had white tiles and the two rooms were theatre, bar and exhibition space in one.

I somehow got into the group around Ivonne and the strange evenings at Mutzek with Russian musicians and the bicycle pipeline to Bahnhof Friedrichstraße to get new vodka.

I recall the performance of—I forgot his name [Rikrit Tiravanija]—an artist cooking Asian food in the space and serving the food to the audience. Often I woke up the next day on a sofa, I did not have a room in the house and always went home to paint. I never had a more timeless feeling than in these two years of 1992 and 1993 in Berlin. The city seemed to sleep, the buildings were abandoned and run down, more artists came, but the rent was so low and often there was no heating, no water, no electricity and the drinks were cheap. Sometimes helping behind the bar and then later drinking for free.

There were no cafes and we drank the beer on the sidewalk. I remember Tom with his huge motorola mobile, but it was before that time and the internet just started, so we knew where we would meet friends and where to hang out, without making many phone calls.

The Friseur and Botschaft .e.V. was different from Mutzek, but also there was an exchange between the two. The Friseur was similar to Mutzek, a bar, club, exhibition space, film theatre in one, and I never really knew, even if I did, what would be happening each night.

Botschaft was a group of artists and filmmakers, people who were already working with the web, people who started to make clubs, like wmf or panasonic and others. I realized that everything held the possibility to be engaged with; exhibition or lecture, party or catalogue, and it was that, which I didn't find in art school.

I remember the lecture of an older Jewish man who spoke about the IG-Farben company. It was not allowed to exist any longer as a company after the war, but through legal tricks and a credit of 1 deutsche mark, they existed and owned real estate all over. I remember

I Want To See Stars

2004

Video loop
2 seconds
Edition of 5

Halina Kliem

2007
Hochschule der Bildenden Künste Berlin,
class of Katharina Sieverding

has lived and worked in Berlin since 1997

ALEXANDERPLATZ 1. Buch-Prolog

1999

Artist book
10 x 27.5 x 38.5 cm / 4 x 10 $^7/_8$ x 15 $^1/_4$ in

1952
born in Vienna, Austria

1967–1971
Höhere Graphische Lehr- und Versuchsanstalt

lived and worked in Berlin from 1973–1980,
then in Vienna, Budapest and London,
and then again in Berlin since 2000

1976
Verkaufsausstellung, solo show, former Fleischhauerei, Oranienplatz

1992
Einige Aspekte der Schuhpflege 1, Bruno Brunnet Fine Arts (Performance)

1999
Gesinnung '99 (with Jonathan Meese), Contemporary Fine Arts

2001
Die Vertreibung der Händler aus dem Tempel, 2yk-Galerie, Kunstfabrik
WANDBILDER, Atelier Jenny Rosemeyer, Oranienburger Straße 3
PR 17, Berlin

Co-organized SO 36.

Founded the movement *DER WANDEL*.
This movement included a magazine, exhibitions and the trip *DER WANDEL in Polen* with
artist friends to Lodz in 2001. Among others who travelled to Lodz were Thomas Helbig,
Thilo Heinzmann, Suse Weber, Tine Furler, Markus Selg, Jenny Rosemeyer, Guido W.
Baudach, Anselm Reyle, Marten Frerichs, Eva-Maria Wilde and André Butzer.

Invited nearly everybody to have a beer and/or a vodka..

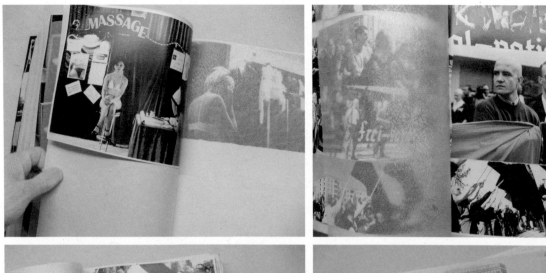

Ein großer Künstler in Berlin

1998

Light box
16 x 20 x 15 cm / 6 ¼ x 7 ⁷/₈ x 5 ⁷/₈ in
Edition of 3

Andreas Koch

1970
born in Stuttgart, Germany

1992–1998
Hochschule der Bildenden Künste Berlin,
class of Dieter Appelt and Christiane Möbus

has lived and worked in Berlin since 1992

I have worked as a graphic designer since 1992, designing the city magazine scheinschlag, the homeless paper motz, and several publications for other artists.

From 1996–2004 I operated Galerie Koch und Kesslau with Sybille Kesslau.

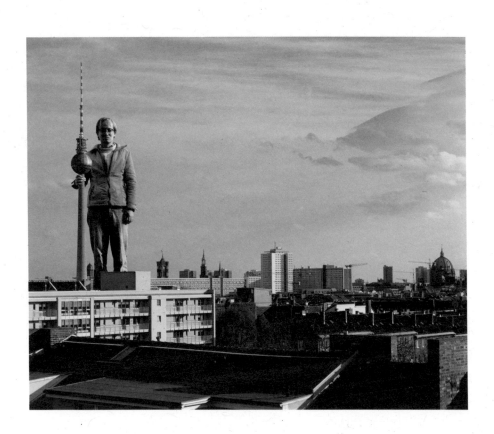

Galatasaray Tanzkulübü

2000

Wood, hardboard, plaster, silkscreen on Formica and neon tubes

Installation view, *Galatasaray Tanzkulübü* at Mysliwska bar, Berlin

Karsten Konrad

1962
born in Würzburg, Germany

1984–1985
Kunstakademie Mainz

1986–1992
Hochschule der Bildenden Künste Berlin,
class of David Evison and Marina Abramovic

1991
Royal College of Art, London, UK

has lived and worked in Berlin since 1985

The Mysliwska bar was established in 1990 by Vitek Marcinkiewicz and I started working there in 1991. In 1996 I opened the club *Galatasaray Tanzkulübü* in the empty back room as a separate disco space.

From 1996–1999 I also worked at the illegal sniper bar (sniper was run by Safy Etiel and Rosa, aka Heinrich Dubel).

I showed my work at loop when they were at Schlegelstraße from 1997–2000, and at Pavillon an der Volksbühne (Rüdiger Lange was the first one to start this project space in 1996/1997). I built the club Halfloop club at loop for Rüdiger, for his Schlegelstraße space.

There were several exciting shows in Berlin that I participated in back at that time: *Z2000*, Quobo 2000 HK art center, SoMA in 1997, *Kunsthalle Moabit* in 1995, *Ceterum Censio* 1998 at Marstall in Berlin (curated by Thomas Wulffen), *sehen-sehen* in 1998 and *16 Räume*, I was also in the *Myslywska* show at Bethanien that Stéphane Bauer organized.

4x5 Pal (Alice)

2000

Acrylic on canvas
Eight canvases, each: 40 x 50 cm / 15 3/4 x 19 3/4 in

Installation view, *Trilemma*, group exhibition, Kunstverein Potsdam, 2001

Alicja Kwade

1979
born in Kattowitz, Poland

1999–2005
Hochschule der Bildenden Künste Berlin

has lived and worked in Berlin since 1999

2000
Zentrale Moabit, Rostockerstr. 51

2001
Trilemma, Kunstverein, Potsdam
Die Vertreibung der Händler aus dem Tempel, 2yk-Galerie, Kunstfabrik
Arbeiten auf Papier, Menschenraum

I mostly hung out in Moabit, Ausstellungsraum, Bar, Beusselkiez, G7 ... Played some music at the Akademie der Künste Berlin, at the Hoschschule, and some other places—forgot where exactly.

Some of my favorite places were: Finks, Marienburgerstraße; Jenny Rosemeyers Wohnung, Oranienburger Straße; dirt, Torstraße; Rio, Chaussestraße; Obst & Gemüse, Oranienburger Straße; G7 Berlin, Oranienburger Straße; Menschenraum, Mulackstraße.

sub syn

1998

Oil, ink and graphite on paper mounted on canvas
Two canvases, each: 200 x 120 cm / 78 ³/₄ x 47 ¹/₄ in;
overall 200 x 240 cm / 78 ³/₄ x 94 ¹/₂ in

Carsten Nicolai

1965
born in Karl-Marx-Stadt, Germany

1985–90
Landscape Design, Dresden

1992
co-founder of VOXXX.Kultur und
Kommunikationszentrum, Chemnitz

1994
founder of noton.archiv für ton und nichtton

1999
label unit raster-noton

lived and worked between Chemnitz,
Berlin and New York from 1994–2000

lives and works in Berlin

I have been working, collaborating and performing in various independent art spaces in former East Berlin, such as Schweiz, BerlinTokyo, Haus Schwarzenberg, Mittwochsbar, sniper etc since the mid-1990s. There was a strong development of artistic networks connecting different non-institutional and art/communication spaces in Leipzig, Chemnitz and Berlin. VOXXX in Chemnitz, which I co-founded, was one of these networking spaces.

After the "Wende," especially Berlin, due to its political and creative freedom, offered huge possibilities to realize all kinds of projects, initiatives, exhibitions, concerts, etc. There was this vacuum that everyone had the freedom to fill with his own visions and ideas, without any restrictions at all—everyone could define his own standards.

ENJOY / SURVIVE / ENJOY . . .

2000

Silk screen print
Sticker in 2 color variants: orange/blue and violet/green
10 cm / 4 in, diameter
Unlimited edition

1962
born in Halle/Saale, Germany

1983–1988
German language and literature studies

1992
Promotion (PhD)
Geste zwischen Expression und Kalkül.
Zur Poetik der Wiener Gruppe

has lived and worked in Berlin since 1984

1992
Bruno Brunnets Show Room, Unter den Linden
Magarinefabrik (today KunstWerke) and Galerie Weisser Elefant

1993
Project *schwundgeld*

1994
private mix at Galerie EIGEN+ART

1996
Opening exhibition, loop – raum für aktuelle kunst, Schillingstraße

Diverse contributions, projects etc. for: scheinschlag, BerlinTokyo, die gestalten, büro friedrich on Friedrichstraße.

Off-spaces that I liked and frequented: BerlinTokyo, panasonic (Invalidenstr.), Init, Kitty Yo! Büro (Torstr.), Staatsbank, Kunst und Technik, Sniper, Discount, Prater, St. Kildas, Chunk, Friedrichstr., 103, WMF (Burgstr., Johannisstr, Ziegelstr.), Ibiza, Maria am Ostbahnhof, Luxus, z-bar, Finks, Torpedokäfer.

Magazines that were important at that time: scheinschlag, sklaven.

Untitled

2000

Oil on canvas
230 x 195 cm / 90 $^1/_2$ x 76 $^3/_4$ in

1964
born in Görlitz, Germany

1988–1993
Hochschule für Bildende Künste Dresden

lives and works in Berlin and London

Frank Nitsche

Garden Party (NASDAQ)
2001 / 2003

Particleboard, paint, photocopies, and plastic
47 x 53 x 53 cm / 18 1/2 x 21 x 21 in

Born in Hildesheim, Germany

1984–1987
Hochschule für Bildende Künste
Braunschweig

1988–1993
Hochschule der Bildenden Künste Berlin

1992
Benefizausstellung, Neue Gesellschaft für Bildende Kunst

1994
Steglitz 1, FBK

1995
Zeichnungen und Modelle, solo show at Galerie Neu

1996
Stralau 1, solo show at Kunsthalle Moabit

1998
Platz, solo show at Galerie Neu
1. berlin biennale für zeitgenössische Kunst, Berlin

1999
Konstruktionszeichnungen, KunstWerke Institute for Contemporary Art

2000
The work shown in this space, neugerriemschneider

Freecustomer.com

2000

Video loop
30 minutes
Edition of 10

1968
born in Geneva, Switzerland

1989
Columbia University, New York, USA

1990–1996
Hochschule der Bildenden Künste Berlin

has lived and worked in Berlin since 1968

Daniel Pflumm also founded and co-founded several clubs and music labels:

elektro 1992–1994

elektro music department 1994–today with Klaus Kotai and Mo Loschelder

panasonic 1995–1997 with Klaus Kotai and Mo Loschelder

Init 1998–2001 with Klaus, Mo and Galerie Neu

In addition to this video, Daniel Pflumm has produced a vinyl record for the exhibition.

Inner haircuts

2000

Oil and paper mounted on canvas
170 x 130 cm / 66 $^1/_4$ x 50 $^3/_4$ in

1963
born in Bochum

1985–1992
Hochschule für Bildende Künste
Hamburg, class of Graubner

has lived and worked in Berlin since 1995

1998–2001
Starship co-founder and editor (Nr.1–4)

1997–1999
Showroom–Laden Schillerstr.

2000
Solo show at Zwinger Galerie
Genre Painting, G7

My favorite places were: Dienstagsbar, Freie Klasse Schröderstr., dirt, Finks and Alt Berlin.

Believe

2002

Laminated panels and neon
275 x 385 x 11 cm / 108 1/4 x 151 1/2 x 4 3/8 in

1970
born in Tübingen, Germany

1990–1997
Staatliche Akademie der Bildenden
Künste Suttgart
Staatliche Akademie der Bildenden
Künste Karlsruhe

has lived and worked in Berlin since 1997

1999
Solo exhibition at Andersen's Wohnung

2000
Luftgitarren, solo exhibition, Montparnasse
Sympathie!, curated by Wawa Tokarski, Montparnasse
Genre Painting, G7
Face the Black, works from the collection of Thomas Zipp, Maschenmode

2001
Beyond, csolo exhibition, Galerie Giti Nourbakhsch
Die Vertreibung der Händler aus dem Tempel, 2yk-Galerie, Kunstfabrik
WANDBILDER, Atelier Jenny Rosemeyer, Oranienburger Straße 3
MONTANA SACRA (Circle 5), ZKM, Karlsruhe

Andersen's Wohnung was an exhibition space run by Claus Andersen in his apartment, funded by a scholarship he received for working in Berlin. Thilo Heinzmann and I joined the project after a few months to co-organize the space. In 2000, following Andersen's Wohnung, I co-founded Montparnasse on Marienstaße with Dirk Bell and Thilo Heinzmann. It was also an artist's run exhibition space, presenting artists friends. *Die Vertreibung der Händler aus dem Tempel* was a group exhibition that Cornelia Brintzinger curated for 2yk-Galerie, presenting artists and friends that I helped gather.

Bars I liked in the early days: dirt and Finks

Off-spaces I liked in the early days: Montparnasse and Andersen's Wohnung

Bars I like these days: Zulle in Marzahn

Off-spaces I like these days: Montgomery and Kwadrat

Off-spaces I like these days: Montgomery and Kwadrat

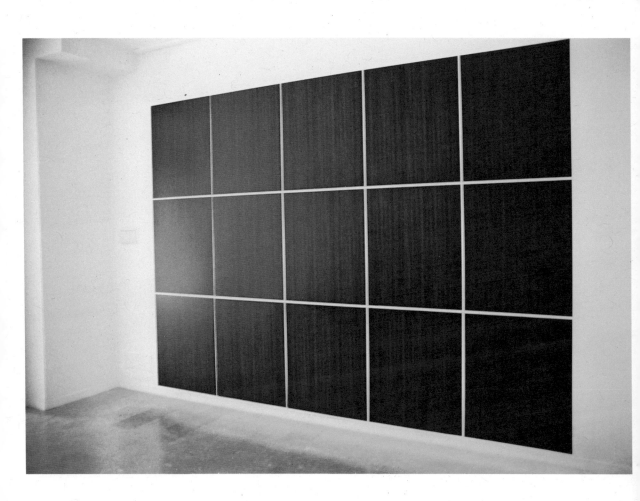

Memorias dos Tempos

2001

Mixed media
Dimensions variable

Installation view, *WANDBILDER*, Atelier Jenny Rosemeyer, Oranienburger Straße 3, Berlin, 2001

Anselm Reyle

1970
born in Tübingen, Germany

1990–1997
Staatliche Akademie der Bildenden
Künste Suttgart
Staatliche Akademie der Bildenden
Künste Karlsruhe

has lived and worked in Berlin since 1997

Katja Strunz

1970
born in Ottweiler, Germany

1991
Philosophy and Fine Art at
Johannes Gutenberg-Universität Mainz

1993
Staatliche Akademie der Bildenden
Künste Karlsruhe

has lived and worked in Berlin since 1998

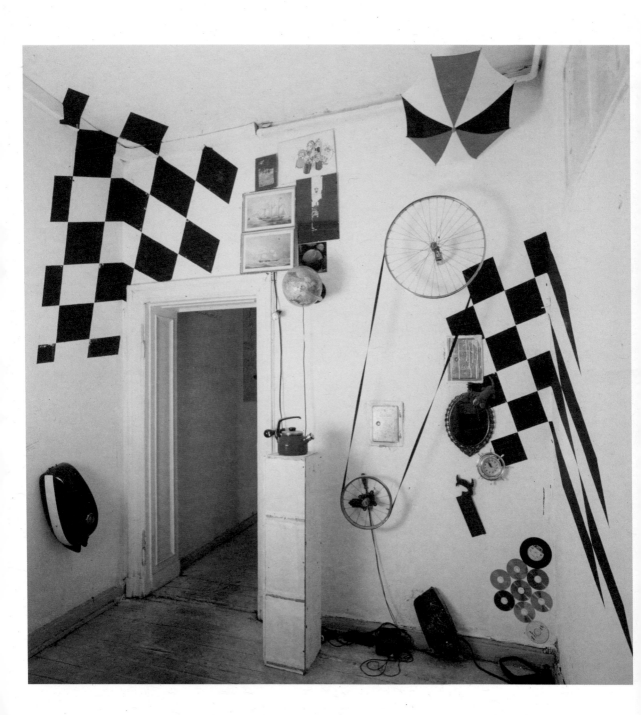

Der 13. Stock

2001

Photo collage
50 x 70 cm / 19 $^{5}/_{8}$ x 27 $^{1}/_{2}$ in

Jenny Rosemeyer

1973
born in Berlin

1994–2002
Hochschule für Bildende Künste Dresden

2000–2001
Columbia University, New York, USA

In 2000 Axel Geis and I organized *WANDBILDER*—a group show at my studio apartment on Oranienburger Straße 3.

Exhibiting artists included: Berta Fischer, Thomas Scheibitz, Lisa Junghanß, Thilo Heinzmann, Eva Maria Wilde, Marten Frerichs, Martin Neumeier, Manfred Peckl, Uwe Henneken, Dani Jakob, Sebastin Hammwöhner, Gabriel Vormstein, Anselm Reyle, Katja Strunz, Axel Geis, Jenny Rosemeyer, Gregor Hildebrandt, Suse Weber, Erwin Kneihsl, Martin Eder, Olaf Holzapfel, Simone Hülser, Martin Eder, Rocco Pagel, Andreas Koch and René Lück.

2000
Genre Painting, G7

2001
MONTANA SACRA (Circle 5), ZKM, Karlsruhe

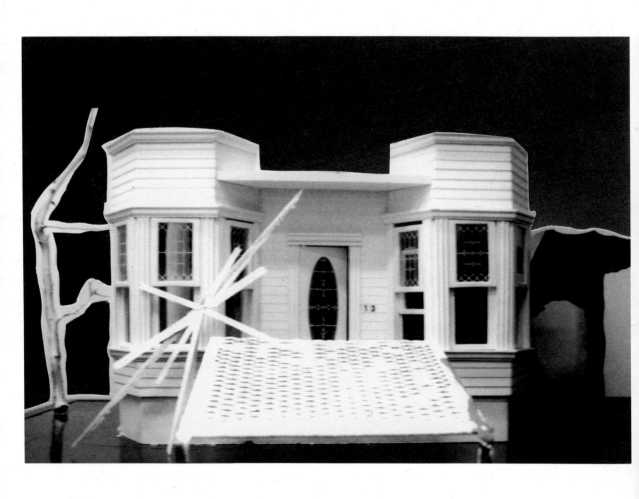

VENUS

2000 / 2001

Oil on canvas
270 x 175 cm / 106 ¼ x 68 ⅞ in

1968
born in Radeberg, Germany

1991–1996
Hochschule für Bildende Künste Dresden,
class of Prof. Kerbach

has lived and worked in Berlin since 1996

1996
Center Court, Hochschule der Künste, Berlin

1998
sehen-sehen – Berlin, '98, loop – raum für aktuelle kunst

1999
In Augenhöhe: Eberhard Havekost, Frank Nitsche, Thomas Scheibitz, Neuer Berliner Kunstverein

2000
Z2000, Akademie der Künste

2001
WANDBILDER, Atelier Jenny Rosemeyer, Oranienburger Straße 3

From what I remember my favorite places in Berlin were:
Montparnasse, an art space organized by Dirk Bell, Thilo Heinzmann and Anselm Reyle
Init Kunsthalle with bar (one of the best places in Berlin)
loop – raum für aktuelle kunst, organized by Rüdiger Lange
Some shows at Galerie Koch und Kesslau

I also liked the exhibitions:
Deutsch Britische Freundschaft: DIE GEFAHR IM JAZZ in the apartment of Thomas Helbig
Genre Painting at G7

And last but not least, in addition to some galleries, the KunstWerke on Auguststrasse

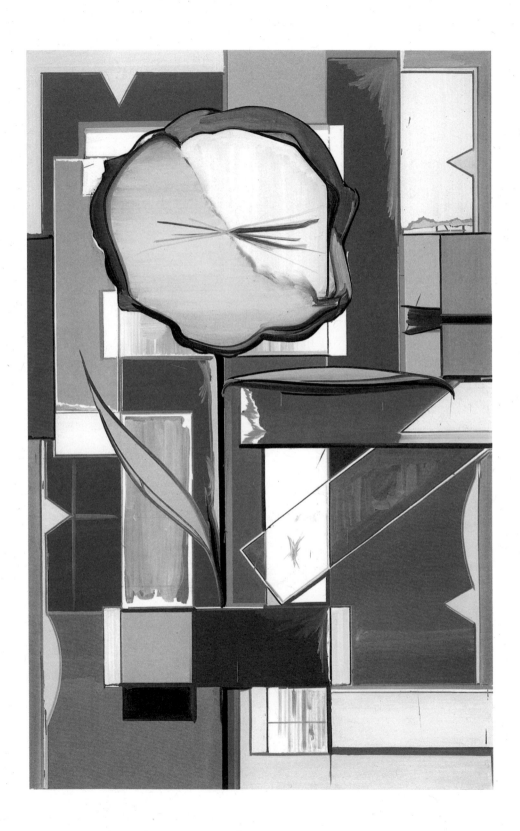

Sightseeing

2000

Oil on canvas
170 x 140 cm / 66 ⁷/₈ x 55 ¹/₈ in

1966
born in Sigmaringen, Germany

1990–1995
Hochschule der Bildenden Künste Berlin,
class of Bernd Koberling

has lived and worked in Berlin since 1987

My first solo show in Berlin was in October of 1997 at loop-raum für aktuelle Kunst, located at Schlegelstraße 27. I was a very close friend of Rüdiger Lange's at that time. That was the inaugural show of the space. Right after came a string of shows by Thomas Scheibitz, Christine Hohenbüchler, Karsten Konrad, and many others.

At the beginning of 1998, Rüdiger Lange organized an overview show of Berlin's art scene entitled *sehen sehen Berlin 98*, an extensive group show that included Scheibitz, Kiesewetter, Stauss, Hohenbüchler, Ackermann, Majerus, Nader, Olaf Nicolai.....

In Schlegelstraße 27, a massive industrial complex, by now renovated. Rüdiger Lange also ran a lounge that was designed by the artist Karsten Konrad.

I was mainly meeting with artists like Thomas Kiesewetter, Thomas Scheibitz and Johannes Kahrs back then.

In September of 2000, the off-space WBD (Wand Boden Decke), a non-commercial exhibition space, opened on Brunnenstraße. It was founded and curated by Martin Städeli (a close friend of mine), Thomas Ravens, and Michael Detlevson. This space was located in the backyard of a building, the ruins of an unfinished building.

WBD did shows of Judith Hopf, Fritz Heisterkamp, Gregor Hildebrandt, Uta Kollmann, René Lück, Peter Piller, Martin Städeli, Thomas Ravens, Gunnar Reski, Peter Stauss, etc. Between 2000 and 2005 this was probably one of the most interesting off-spaces.

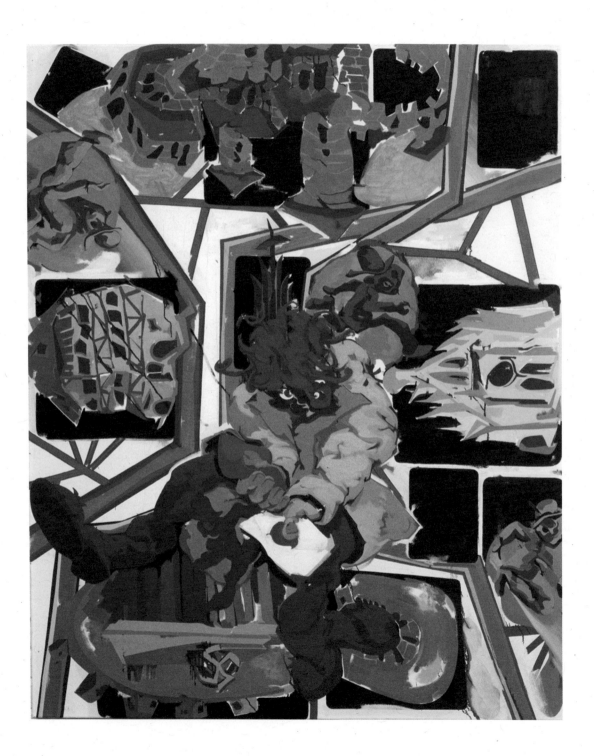

Untitled

2001

Metal
94 x 128 x 23.8 cm / 37 x 50 $^3/_8$ x 9 $^3/_8$ in

1970
born in Ottweiler, Germany

1991
Philosophy and Fine Art at
Johannes Gutenberg-Universität Mainz

1993
Staatliche Akademie der Bildenden
Künste Karlsruhe

has lived and worked in Berlin since 1998

1998
Thilo Heinzmann, Bernd Krauß, Katja Strunz, Thomas Zipp, Andersen's Wohnung, Berlin

2000
Katja Strunz, solo show, Galerie Giti Nourbakhsch
Sympathie!, curated by Wawa Tokarski, Montparnasse
Landscape, Galerie Giti Nourbakhsch

2001
MONTANA SACRA (Circle 5), ZKM, Karlsruhe
WANDBILDER, Atelier Jenny Rosemeyer, Oranienburger Straße 3
Die Vertreibung der Händler aus dem Tempel, 2yk-Galerie, Kunstfabrik

My favorite places in Berlin today are: Cruise & Callas, back then: Montparnasse.

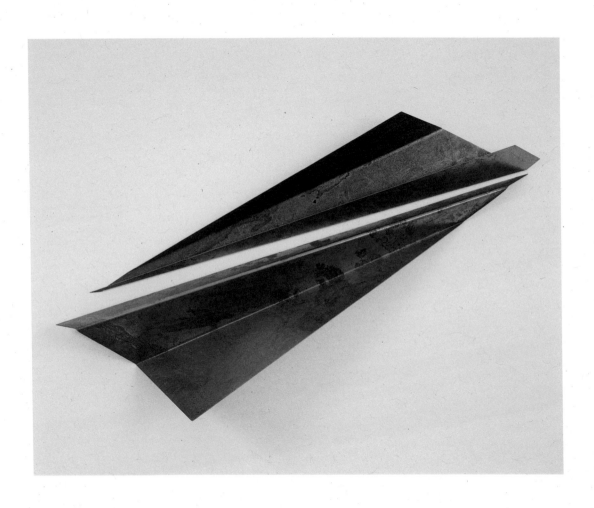

O.T.

1994

Watercolor on paper
43 x 60 cm / 17 x 23 5/8 in

Wawrzyniec Tokarski

1968
born in Gdansk, Poland

1986–1988
State Academy of Fine Arts,
Gdansk, Poland

1989–1991
Staatliche Akademie der Bildenden
Künste Stuttgart

1991–1997
Staatliche Akademie der Bildenden
Künste Karlsruhe

has lived and worked in Berlin since 2000

In 2000 I didn't exhibit much in Berlin, if I remember correctly. I took part in an exhibition in the Haus der Kulturen der Welt (House of the World's Cultures) with a video installation. Showed a student video once in a video program at Giti N. Before 2000 there was a lot of Berlin trash spaces that I liked. Stephan Jung did Invalidenstraße 31 with Yvonne Hader where, in '91 or '92 I exhibited with Simone Westerwinter. Later there was a club there, panasonic, run by Daniel Pflumm. Before that, Pflumm had also made some other good spaces such as The Electro. Around the corner from that was a hairdresser and at the beginning of the '90s The Embassy was also a cool address, but all of that was a decade before. That was also the period of the first genuine trash, which all those who came to Berlin around 2000 wanted to join in. So I only came back to Berlin again in 2000 to live here.

In 2000, *the* space was Marienstr. 1 in Berlin-Mitte and was called Montparnasse. Whether it was my favorite space is another story, but in any case I was often there. The associated club was called Finks, I think. For me, the address was more important than the name. I already have enough problems with remembering street names. The space was made by Dirk Bell together with Anselm Reyle and Thilo Heinzmann, and it was a club with a small exhibition space. I didn't exhibit there myself, or play DJ, but in June 2000 I organized a trailblazing group exhibition called *Sympathie!*. I invited people whom I found to be sympatico at that time. The relationship did not have to be intensive, and they did not have to be artists. I did not like all of them particularly. There were also lots of other practical factors, which in the end were decisive in determining who took part. A lot could be said about that. But the exhibition was supposed to become, so to speak, the touchstone for my sentiments, and that's what it became. In practice it distinguished itself from other initiatives of this kind in several ways:

1) There was no opening—only the setting-up—which then turned into a party, because some of the works had a processual character, such as the smoke machine by Katja Strunz and the music which Vormstein, Henneken and Hammwöhner put on the turntable, and these works existed only as long as the setting-up party was going on. For this setting-up party there was, effectively, also an invitation, and people also came by, but it was a matter of confronting the spectators (in case there were any) not with a 'ready relic' which an exhibition becomes after being set up, but with a lively, dynamic situation where everything could still go wrong. So all of that was made public.

2) The participants for the most part did not provide any works from their oeuvre at that time for the exhibition, but the way they participated came about in an interaction with me, yes indeed. (often they were rather queer constructs).

3) Because the exhibition space was very small, the works had to occupy, so to speak, various levels of the space (and that was good). They were not exhibited next to one another. Klaus Winichner had provided a counter which was a part of the infrastructure on which the other things could be shown and discs played. Anselm took care of the lighting. Katja's work really consisted only of the fog in the room, so one could say that she had worked with air. Heike Föll carried her diary with her. The work of the other three could be heard. There was an internally controversial painting (by Michel Majerus). There was also a wall decoration by Heidi Specker which was derived from the aesthetics with which her photos were preoccupied. But I want to underscore that in the overall conception of the exhibition, there was no juxtaposition, as it later became usual to fill spaces to the brim with little pictures.

4) After setting up, the room was locked up, along with all of the party trash (beer bottles, vomit, people had put out their cigarettes in Plamen's/Swetlana's glass model BMW) and from then on it could only be seen through the shop window at the front. That is, so to speak, the relic phase that normally constitutes an exhibition. Period.

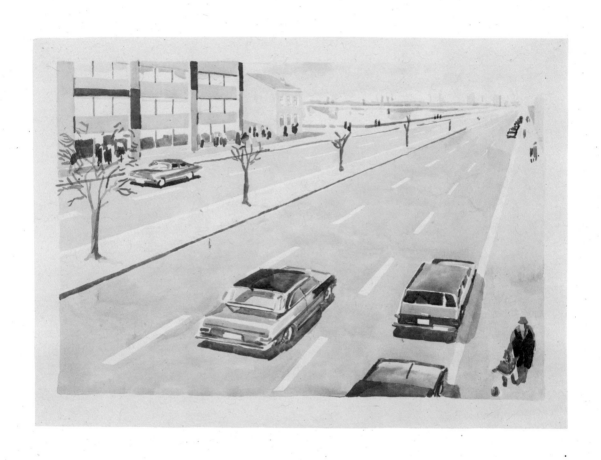

Salem

2000

Wood, lacquer, plaster, pineapple, mango, pomegranate
210 x 20 x 40 cm / 82 $^3/_4$ x 8 x 15 $^3/_4$ in

Gabriel Vormstein

1974
born in Konstanz, Germany

1995–2001
Staatliche Akademie der Bildenden
Künste Karlsruhe

has lived and worked in Berlin since 2001

2000
Corriger la fortune, Montparnasse
Sympathie!, curated by Wawa Tokarski, Montparnasse
Face the Black, works from the collection of Thomas Zipp, Maschenmode

2001
MONTANA SACRA (Circle 5), ZKM, Karlsruhe
WANDBILDER, Atelier Jenny Rosemeyer, Oranienburger Straße 3

I liked to hang out at Dirk Bell's Finks bar.

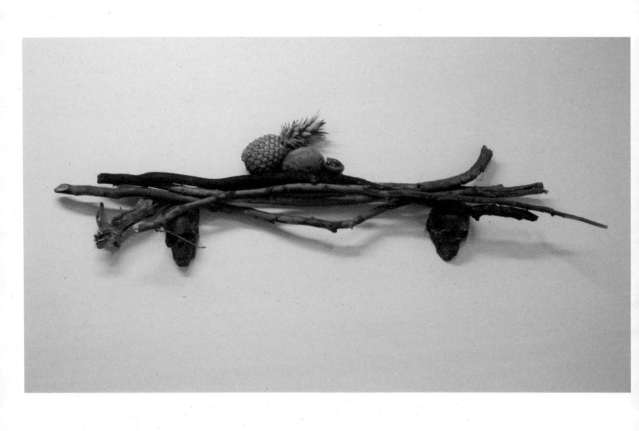

Der Adler

1999

German Eagle consisting of East-German sports medals

600 cm red ribbon
400 cm chain
1 golden cord
26 medals, self-won in Leipzig
54 swing hooks

250 x 300 cm / 118 1/8 x 157 1/2 in

Installation view, *SchwarzblutNeid*, Maschenmode, Berlin, 2001

1970
born in Leipzig, Germany

1995–2000
Hochschule der Bildenden Künste Berlin

has lived and worked in Berlin since 1990

2000
Genre Painting, G7

2001
MONTANA SACRA (Circle 5), ZKM, Karlsruhe
DER WANDEL, Glasgow, Maschenmode
WANDBILDER, Atelier Jenny Rosemeyer, Oranienburger Straße 3
Die Vertreibung der Händler aus dem Tempel, 2yk-Galerie, Kunstfabrik

Solo shows at Maschenmode in 2001 and 2002

Publishing a photo magazine in small edition parallel to sexybar by Olivia Berckemeier and Suse Weber, works shown by Dani Jakob, Kalin Lindena, Tine Furler. . . .

Bouncer at dirt

Regularly visiting Finks and Init

DER WANDEL in Polen trip to Lodz, drank with others and translated badly into Russian

SEXY BAR
sexy bar is the forerunner of Schickeria

Founding members of sexy bar are Katja Strunz, Tine Furler, Tatjana Doll, Katrin Middel, Eva Färber, Suse Weber, Olivia Berckemeyer

2001
Formation meeting at the apartment of Tine Furler
Ordinance: women play the music and run the bar at least three of the founding members have to be present, to call themselves sexy bar

1. Station: Studio Charité (former Galerie Neu, at that time studio of Suse Weber), parallel to Berlinale, a certain number of emerging male actors are hanging out, Thilo Heinzmann chips in the windows from, imagining himself to still be at Galerie Neu

2. Station: a truck, parking lot at Nordbahnhof, Tatjana Doll builts the bar. Suse Weber organizes the truck for a "testrun" claiming she is a potential buyer, the light is made with torches, the record player runs on batteries

3. Station: Spree Beach

4. Station: Menschenraum, Wagner and Brahms are being combined with East-German records. Suse Weber wears a black eye, Gabriel Vormstein arrives with a real black eye

5. Station: house squatting on Brunnenstraße for one night, closed by special police forces, due to suspicion of celebrating the birthday of Adolf Hitler! (reported by a neighbor), gig by Planningtorock

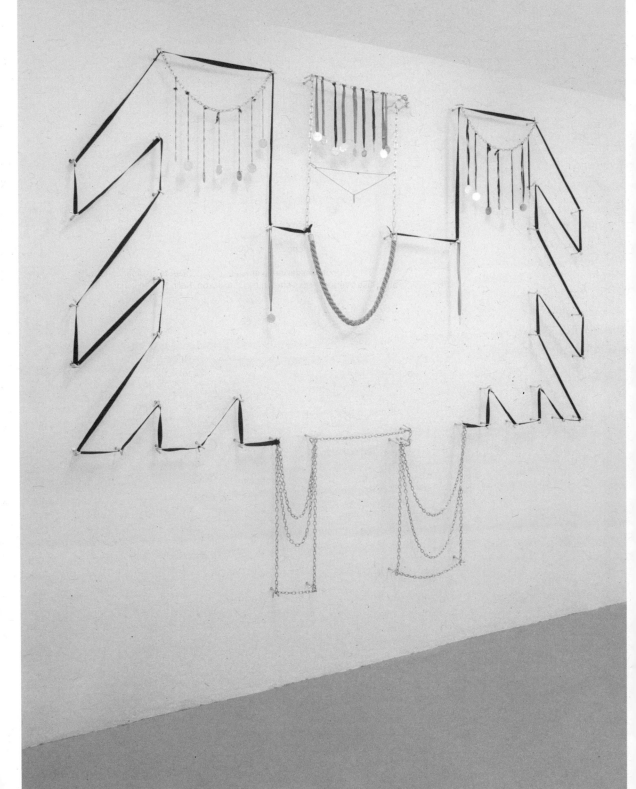

Bubble Head

2001

C-Print
136 x 105.5 cm / 53 1/2 x 41 1/2 in

Tilman Wendland

1969
born in Potsdam, Germany

1992–1999
Visual Communication at Hochschule der Bildenden Künste Berlin

has lived and worked in Berlin since 1985

In 2000 I received a scholarship from the Akademie der Künste in Berlin (by Hanns Schimansky), which I used to organize the project MEISTERSCHULE with my cousin Ulrich Wendland.

2000
Bleibe, Z2000, Akademie der Künste
Among the exhibiting artists were: Franz Ackermann, Richard Billingham, Christine Borland, Olafur Eliasson, Douglas Gordon, Katharina Grosse, Hans-Dirk Hotzel, Peter Land, Jörg Lenzlinger/Gerda Steiner, Novaphorm (Lisa Junghanß and Martin Eder) and Bojan Sarcevic

Werkausstellung der Stipendiaten, Akademie der Künste, Galerie Künstlerhof Berlin-Buch

2001
Schaumkopf, Koch und Kesslau
Booth for Koch und Kesslau, Art Forum Berlin

Bars I liked were: dirt and Luxusbar.

Tilman Wendland will create a special interactive installation. This platform will feature a historical trove of catalogues, articles, interviews and films in support of the exhibition.

...istan passiert

2000 / 2001

Mixed media (four pieces)
170 x 240 cm / 67 x 94 1/2 in

Installation view, *sexuell*, group exhibition, Stiftung Starke, Berlin, 2001

Thomas Zipp

1966
born in Heppenheim, Germany

1992–1998
Städel, Hochschule für Bildende
Künste, Frankfurt/Main

1996
Slade School, London, UK

has lived and worked in Berlin since 1997

Spaces organized: dirt, Nov. 2000–May 2001, Menschenraum, 2000–2004.

Exhibitions curated: several, among others Menschenraum.

Showed at/with: many places with many people.

Played music at: dirt, Twen FM.

Had a beer or two at/with: many places with many people.

**Just what is it that makes today's
Berlin so different and appealing?**

Cover of the first issue of STARSHIP magazine, 1998

Hans-Christian Dany

born in Hamburg in 1966 is a visual artist
and writer. 1991 he founded the magazine
Dank and 1998 the magazine STARSHIP.
His most recent book is *Speed, eine
Gesellschaft auf Droge* (a society on drugs)

Martin Ebner

born in Austria 1965, is a visual artist living
in Berlin and co-publisher of STARSHIP
magazine. His recent work was on display at
Herald St., London, Extra City, Antwerp and
Berlinale Film Festival (Forum Expanded), Berlin

Ariane Müller

is a visual artist and writer born in Vienna,
living in Berlin. In 1991 she founded the
magazine Artfan and in 1998 the magazine
STARSHIP. She has been showing at the
Museum of Modern Art Sydney, Havana
Biennial, Museum of Modern Art Vienna and
co-curated the Werkleitz Biennial in 2004

STARSHIP is an art magazine produced by artists and a platform for exhibitions, concerts,
cinema and books. STARSHIP is also an exhibited artist collective in various forms
centered around the editors Hans-Christian Dany, Martin Ebner and Ariane Müller.

STARSHIP was founded in Berlin in 1998.

STARSHIP is contributing a special edition to the exhibition.

STARSHIP (Hans-Christian Dany /Martin Ebner / Ariane Müller)

star ship

Nr. 1
DM 5 ÖS 35

Just what is it
that makes today's Berlin
so different, so appealing?

Herbst 1998

All artist biographies and statements were edited specifically for this exhibition catalogue.

53 Dirk Bell

Untitled
2002
Mixed media on paper
38.9 x 28.7 cm / 15 ¼ x 11 ¼ in
Collection of Martin and Rebecca Eisenberg
© 2009 Dirk Bell
Photograph courtesy Gavin Brown's enterprise, New York

55 John Bock

1 Million $ Knödel Kisses
2001–2002
Mixed media
Dimensions variable
Courtesy the artist, Anton Kern Gallery, New York
and Galerie Klosterfelde
© 2009 John Bock
Photograph courtesy Anton Kern Gallery, New York

57 Monica Bonvicini

2 Tonnen Alte Nationalgalerie
1998
Rubble from the façade of the
Alte Nationalgalerie, Berlin
Dimensions variable
Courtesy the artist and Galleria Emi Fontana, Milan,
West of Rome, Los Angeles
© 2009 Artists Rights Society (ARS), New York /
VG Bild-Kunst, Bonn
Photograph by Jens Ziehe

59 André Butzer

Friedens-Siemens I
2000
Acrylic and oil on canvas
230 x 165 cm / 90 ½ x 65 in
Courtesy the artist and Galerie Guido W. Baudach, Berlin
© 2009 André Butzer
Photograph by Roman März

61 Björn Dahlem

Club Schrödingers Katze
2000 / 2009
Wood, fluorescents, carpet, cat tree,
cat litter, book and lamp
Dimensions variable
Courtesy the artist and Galerie Guido W. Baudach, Berlin
© 2009 Björn Dahlem
Photograph by the artist

63 Martin Eder

**The Skinned Rabbit's
Running Nose**
2001
Wallpainting
Courtesy Galerie EIGEN+ART Leipzig/Berlin
© 2009 Artists Rights Society (ARS), New York /
VG Bild-Kunst, Bonn
Photograph courtesy Jenny Rosemeyer

**65 Sebastian Hammwöhner /
Dani Jakob / Gabriel Vormstein**

Untitled (Dürersee)
2000
Watercolor and graphite on newspaper and
Chinese paper, pastel on cardboard
215 x 250 cm / 84 ⅝ x 98 ⅜ in
Courtesy the artists
© 2009 Sebastian Hammwöhner, Dani Jakob and
Gabriel Vormstein
Photograph courtesy Gabriel Vormstein

67 Thilo Heinzmann

o.T.
1999
Pigment and epoxy on styrofoam in
plexiglass case
152 x 202 x 11 cm / 59 ⅞ x 79 ½ x 4 ⅜ in
Courtesy the artist, Galerie Guido W. Baudach, Berlin
and Bortolami Gallery, New York
© 2009 Thilo Heinzmann
Photograph by Roman März

69 Thomas Helbig

Ikone

2000–2001

Oil on canvas

158 x 135 cm / 62 ¼ x 53 ⅛ in

Courtesy the artist and Galerie Guido W. Baudach, Berlin
© 2009 Thomas Helbig
Photograph by Roman März

71 Uwe Henneken

Solitude

2001

Oil on canvas

50 x 40 cm / 19 ¾ x 15 ¾ in

Collection of Susan R. Crossley and Timothy Collins
© 2009 Uwe Henneken
Photograph courtesy the artist and Contemporary
Fine Arts, Berlin

73 Gregor Hildebrandt

Alice im Wandel (7. Januar 79)

2001

Cassette tape and mixed media on paper

41.2 x 29.6 cm / 16 ¼ x 11 ¼ in

Courtesy Wentrup, Berlin
© 2009 Gregor Hildebrandt
Photograph by Roman März

75 Sofia Hultén

Getting Rid of Stuff

2001

Video loop

7 minutes

Edition of 20 + 1 AP

Courtesy the artist and Natalia Goldin Gallery,
Stockholm
© 2009 Artists Rights Society (ARS), New York /
VG Bild-Kunst, Bonn
Stills courtesy the artist

77 Klaus Jörres

TYCO NOT TYCO

2000 / 2001

Slot car racetrack, MDF

180 x 240 x 50 cm / 70 ⅞ x 94 ½ x 19 ¾ in

© 2009 Klaus Jörres
Photograph by Gert Bendel

79 Lisa Junghanß

my mommy part II

2000

Video loop

6 minutes

Edition of 3 + 2 AP

© 2009 Lisa Junghanß
Still courtesy the artist

83 Johannes Kahrs

Untitled (Schmerz)

1994–1996

Oil on canvas

110 x 165 cm / 43 ¾ x 65 in

Courtesy the artist and Luhring Augustine, New York
© 2009 Artists Rights Society (ARS), New York /
VG Bild-Kunst, Bonn
Photograph courtesy the artist, Luhring Augustine,
New York and Zeno X Gallery, Antwerp

85 Halina Kliem

I Want To See Stars

2004

Video loop

2 seconds

Edition of 5

© 2009 Halina Kliem
Still courtesy the artist

87 Erwin Kneihsl

ALEXANDERPLATZ 1. Buch-Prolog

1999

Artist book

10 x 27.5 x 38.5 cm / 4 x 10 ⅞ x 15 ¼ in

Courtesy the artist and Galerie Guido W. Baudach, Berlin
© 2009 Erwin Kneihsl
Photography by the artist

89 Andreas Koch

Ein großer Künstler in Berlin

1998

Light box

16 x 20 x 15 cm / 6 ¼ x 7 ⅞ x 5 ⅞ in

Edition of 3

Courtesy loop – raum für aktuelle kunst, Berlin
© 2009 Andreas Koch
Photograph courtesy the artist

91 Karsten Konrad

Galatasaray Tanzkulübü

2000

Wood, hardboard, plaster, silkscreen on
Formica and neon tubes

Courtesy loop – raum für aktuelle kunst, Berlin
© 2009 Karsten Konrad
Photograph by Martin Eberle

93 Alicja Kwade

4x5 Pal (Alice)

2000

Acrylic on canvas

Eight canvases, each: 40 x 50 cm /
15 ¾ x 19 ¾ in

Courtesy the artist and Galerie Johann König, Berlin
© 2009 Alicja Kwade
Photograph courtesy the artist

95 Carsten Nicolai

sub syn
1998
Oil, ink and graphite on paper mounted
on canvas
Two canvases, each: 200 x 120 cm /
78 3/4 x 47 1/4 in; overall 200 x 240 cm /
78 3/4 x 94 1/2 in
Courtesy Galerie EIGEN+ART Leipzig/Berlin
© 2009 Artists Rights Society (ARS), New York /
VG Bild-Kunst, Bonn
Photograph by Uwe Walter

97 Olaf Nicolai

ENJOY / SURVIVE / ENJOY . . .
2000
Silk screen print
Sticker in 2 color variants: orange/blue and
violet/green
10 cm / 4 in, diameter
Unlimited edition
Courtesy Galerie EIGEN+ART Leipzig/Berlin
© 2009 Artists Rights Society (ARS), New York /
VG Bild-Kunst, Bonn

99 Frank Nitsche

Untitled
2000
Oil on canvas
230 x 195 cm / 90 1/2 x 76 3/4 in
Courtesy Galerie Gebr. Lehmann, Berlin/Dresden
© 2009 Frank Nitsche
Photograph courtesy Galerie Gebr. Lehmann, Berlin/Dresden

101 Manfred Pernice

Garden Party (NASDAQ)
2001 / 2003
Particleboard, paint, photocopies, and plastic
47 x 53 x 53 cm / 18 1/2 x 21 x 21 in
Courtesy the artist, Anton Kern Gallery, New York and
Galerie Neu, Berlin
© 2009 Manfred Pernice
Photograph by Thomas Müller

103 Daniel Pflumm

Freecustomer.com
2000
Video loop
30 minutes
Edition of 10
Courtesy the artist and Galerie Neu, Berlin
© 2009 Daniel Pflumm
Still courtesy Galerie Neu, Berlin

105 Gunter Reski

Inner haircuts
2000
Oil and paper mounted on canvas
170 x 130 cm / 66 1/4 x 50 3/4 in
Courtesy the artist and ZWINGER Galerie, Berlin
© 2009 Gunter Reski
Photograph courtesy the artist

107 Anselm Reyle

Believe
2002
Laminated panels and neon
275 x 385 x 11 cm /
108 1/4 x 151 1/2 x 4 3/8 in
Courtesy Anselm Reyle Studio and Gagosian Gallery
© 2009 Artists Rights Society (ARS), New York /
VG Bild-Kunst, Bonn
Photograph courtesy the artist

109 Anselm Reyle / Katja Strunz

Memorias dos Tempos
2001
Mixed media
Dimensions variable
Courtesy the artists
© 2009 Artists Rights Society (ARS), New York /
VG Bild-Kunst, Bonn
© 2009 Katja Strunz
Photograph by Katja Strunz

111 Jenny Rosemeyer

Der 13. Stock
2001
Photo collage
50 x 70 cm / 19 5/8 x 27 1/2 in
© 2009 Jenny Rosemeyer
Photograph courtesy the artist

113 Thomas Scheibitz

VENUS
2000 / 2001
Oil on canvas
270 x 175 cm / 106 1/4 x 68 7/8 in
Collection of the artist
Courtesy Tanya Bonakdar Gallery, New York
© 2009 Artists Rights Society (ARS), New York /
VG Bild-Kunst, Bonn
Photograph by Jens Ziehe

115 Peter Stauss

Sightseeing
2000
Oil on canvass
170 x 140 cm / 66 7/8 x 55 1/8 in
Courtesy the artist and Aurel Scheibler, ScheiblerMitte, Berlin
© 2009 Peter Stauss
Photograph by Simon Vogel, Köln

117 Katja Strunz

Untitled
2001
Metal
94 x 128 x 23.8 cm / 37 x 50 3/8 x 9 3/8 in
Courtesy Gavin Brown's enterprise, New York and
Contemporary Fine Arts, Berlin
© 2009 Katja Strunz
Photograph courtesy Gavin Brown's enterprise, New York

119 Wawrzyniec Tokarski

O.T.
1994
Watercolor on paper
43 x 60 cm / 17 x 23 5/8 in
Courtesy Wentrup, Berlin
Photograph by Roman März

121 Gabriel Vormstein

Salem
2000
Wood, lacquer, plaster, pineapple,
mango, pomegranate
210 x 20 x 40 cm / 82 3/4 x 8 x 15 3/4 in
Courtesy the artist and Casey Kaplan Gallery, New York
© 2009 Gabriel Vormstein
Photograph courtesy the artist

123 Suse Weber

Der Adler
1999
German Eagle consisting of East-German
sports medals

600 cm red ribbon
400 cm chain
1 golden cord
26 medals, self-won in Leipzig
54 swing hooks

250 x 300 cm / 118 1/8 x 157 1/2 in
Courtesy Galerie Gebr. Lehmann, Berlin/Dresden
© 2009 Suse Weber
Photograph courtesy Galerie Gebr. Lehmann, Berlin/Dresden

125 Tilman Wendland

Bubble Head
2001
C-Print
136 x 105.5 cm / 53 1/2 x 41 1/2 in
© 2009 Tilman Wendland
Photograph courtesy the artist

127 Thomas Zipp

. . . istan passiert
2000 / 2001
Mixed media (four pieces)
170 x 240 cm / 67 x 94 1/2 in
Courtesy the artist and Galerie Guido W. Baudach, Berlin
© 2009 Thomas Zipp
Photograph by the artist

**129 STARSHIP (Hans-Christian Dany /
Martin Ebner / Ariane Müller)**

**Just what is it that makes today's
Berlin so different and appealing?**

Cover of the first issue of STARSHIP
magazine, 1998
© 2009 *STARSHIP* Magazine, Berlin
Photograph courtesy Martin Ebner

Notes on photography

Cover

Gabriel Vormstein at *Sympathie!,* Montparnasse on Marienstraße, 2000.

Photograph courtesy Wawrzyniec Tokarski

Back cover, pages 6 (left), **14–15**

WANDBILDER. Group exhibition curated by Jenny Rosemeyer and Axel Geis. The exhibition was held at Atelier Jenny Rosemeyer, Oranienburger Straße 3, 2001. The exhibition included artists such as Martin Eder, Berta Fischer, Marten Frerichs, Axel Geis, Sebastian Hammwöhner, Thilo Heinzmann, Uwe Henneken, Gregor Hildebrandt, Olaf Holzapfel, Simone Hülser, Dani Jakob, Lisa Junghanß, Erwin Kneihsl, Andreas Koch, René Lück, Martin Neumeier, Rocco Pagel, Manfred Peckl, Anselm Reyle, Thomas Scheibitz, Katja Strunz, Gabriel Vormstein, Suse Weber and Eva-Maria Wilde.

Photograph by Jenny Rosemeyer

Pages 1, 81

dirt. Artist's place conceived by Thomas Zipp and run in collaboration with Guido W. Baudach. Located next to Maschenmode on Torstraße (2000–2001).

Photograph by Erwin Kneihsl

Pages 2–3

Electric Favela. Outdoor club in the backyard of the gallery loop – raum für aktuelle kunst on Schlegelstraße, during the summer of 1999. The club was designed by Karsten Konrad and Achim Kobe.

Photograph courtesy Karsten Konrad

Pages 4–5

Sniper. Illegal club that served Chinese beer and Vietnamese vodka with videos and DJ sets by Safy Etiel and co-organizer Rosa (aka Heinrich Dubel). The club was located at Rosenthaler Straße (1996–2003).

Photograph courtesy Karsten Konrad

Page 6 (right)

Suse Weber, *Maskerade*, 2007, chromogenic print on paper, 100 x 150 cm / 39 $^3/_8$ x 59 in, edition of 7. This photo was taken at the Autocenter exhibition space, run by Joep van Liefland and Maik Schierloh on Eldenaer Straße, where Suse Weber asked artist friends to remain anonymous by wearing a mask of their own making.

Courtesy Galerie Gebr. Lehmann, Berlin/Dresden
© 2009 Suse Weber
Photograph courtesy Galerie Gebr. Lehmann, Berlin/ Dresden

Page 7 (left)

Anselm Reyle and Katja Strunz, *Memorias dos Tempos*, 2001, mixed media, dimensions variable

Courtesy the artists
© 2009 Artists Rights Society (ARS), New York /
VG Bild-Kunst, Bonn
© 2009 Katja Strunz
Photograph by Katja Strunz

Page 7 (right)

Sympathie! Group exhibition curated by Wawrzyniec Tokarski at Montparnasse on Marienstraße, 2000. The exhibition included artists such as Plamen Dejanov & Swetlana Heger, Dieter Detzner, Heike Föll, Sebastian Hammwöhner, Uwe Henneken, Stephan Jung, Maureen Karcher, Michel Majerus, Karin Pernegger, Anselm Reyle, Susa Reinhardt, Heidi Specker, Katja Strunz, Alexandra Trenséni, Gabriel Vormstein and Klaus Winichner.

Photograph courtesy Wawrzyniec Tokarski

Page 11 (top)

Genre Painting. Group exhibition curated by Gregor Hildebrandt, Marc Pätzold, Susanne Roewer and Roger Wardin at G7, Oranienburger Straße, 2000. The exhibition featured over a hundred artists, including Dirk Bell, Axel Geis, Sebastian Hammwöhner, Thilo Heinzmann, Thomas Helbig, Uwe Henneken, Andreas Hofer, René Lück, Michel Majerus, Gunter Reski, Anselm Reyle, Jenny Rosemeyer, Thomas Scheibitz, Dirk Skreber, Gert and Uwe Tobias, Wawrzyniec Tokarski, Gabriel Vormstein, Suse Weber and Thomas Zipp.

Photograph courtesy Marc Pätzold

Page 11 (center left)

Pavillon an der Volksbühne. Exhibition space located on Rosa-Luxemburg-Platz. From 1997 to 1998 curated by Rüdiger Lange (loop – raum für aktuelle kunst) with an extensive exhibition program and regular public screenings of crucial soccer matches. *ready mix*, 1997, the inaugural exhibition by Erik Göngrich is shown.

Photograph by Rüdiger Lange

Page 11 (center right)

Deutsch Britische Freundschaft: DIE GEFAHR IM JAZZ. Poster for the group exhibition organized by Thomas Helbig, Keith Farquhar (Deutsch Britische Freundschaft) and Lucy McKenzie, Straßburger Straße, 2000.

Photograph courtesy Thomas Helbig

Page 11 (bottom)

Sympathie! Flyer for the group exhibition curated by Wawrzyniec Tokarski at Montparnasse on Marienstraße, 2000.

Photograph courtesy Wawrzyniec Tokarski

Page 26 (top)

FAT ROB/SLIM ROB. Performance by Diego Castro the founder of BergstüblPROJEKTE, 2000.

Photograph by Anne Jalsoe

Page 26 (bottom)

Berühmte Künstler helfen Koch und Kesslau. Opening reception for the group exhibition at Koch und Kesslau, 2000. In the foreground are Rirkrit Tiravanija and Andreas Koch.

Photograph courtesy Andreas Koch

Page 27 (top)

Koch und Kesslau. Opening reception for the exhibition *Stefan Beuchel*, 2000. In the foreground are Gregor Hildebrandt and René Lück.

Photograph courtesy Andreas Koch

Page 27 (bottom)
BergstüblPROJEKTE. Exhibition space located on Veteranenstraße above the Bergstübl bar and run by Diego Castro, Ingo Gerken and Stephan Kallage from 2000 to 2004. *Stretched Impact (Neue Nationalgalerie)*, 2002 by Ingo Gerken is shown.
Photograph by Ingo Gerken

Page 34 (top)
Halfloop. Bar designed by Karsten Konrad and Achim Kobe located at loop – raum für aktuelle kunst, Schlegelstraße (1998–2001).
Photograph courtesy Karsten Konrad

Page 34 (bottom)
Pavillon an der Volksbühne. *Poelzig Hovercraft*, 1997, an exhibition by Karsten Konrad is shown.
Photograph courtesy Karsten Konrad

Page 35 (top)
Sympathie! Group exhibition curated by Wawrzyniec Tokarski at Montparnasse on Marienstraße, 2000. The artists Gabriel Vormstein and Sebastian Hammwöhner are seen at the right.
Photograph courtesy Wawrzyniec Tokarski

Page 35 (lower left)
Galatasaray Tanzkulübü. Disco designed by Karsten Konrad in the backroom of Mysliwska bar on Schlesischestraße. Opened in 1996, and still in operation.
Photograph courtesy Karsten Konrad

Page 35 (lower right)
panasonic. Club on Invalidenstraße run by Daniel Pflumm, Klaus Kotai and Mo Loscheder (1995–1997).
Photograph courtesy Daniel Pflumm

Page 38
Gregor Hildebrandt dressed as a Turkish supporter of the project *Kreisverkehr*. This autographed photograph was designed for the concept presentation of the project.
Photograph courtesy Suse Weber

Page 39 (top)
Shown is the truck that was used for the concept presentation of the project *Kreisverkehr* and also as *sexy bar* for one night.
Photograph courtesy Suse Weber

Page 39 (bottom)
The Berlin Motorcycle Sporting Group
Photograph courtesy Suse Weber

Catalogue © 2009 PaceWildenstein
Text by Birte Kleemann © 2009 Birte Kleemann
Text by Ariane Müller © 2009 Ariane Müller
Text by Gunter Reski © 2009 Gunter Reski
Text by Marcus Steinweg © 2009 Marcus Steinweg
Interview with Andreas Koch and Benita Piechaczek © 2009 Andreas Koch and Benita Piechaczek

Texts translated from the German by Dr. Michael Eldred, artefact text & translation, Cologne

Design:
Tomo Makiura
Sandra Watanabe

Production:
PaceWildenstein

Color correction:
Motohiko Tokuta

Printing:
Meridian Printing, East Greenwich, Rhode Island

Library of Congress Control Number: 2009922536
ISBN: 9781930743977